THE
Archive Photographs
SERIES

AROUND
HALIFAX

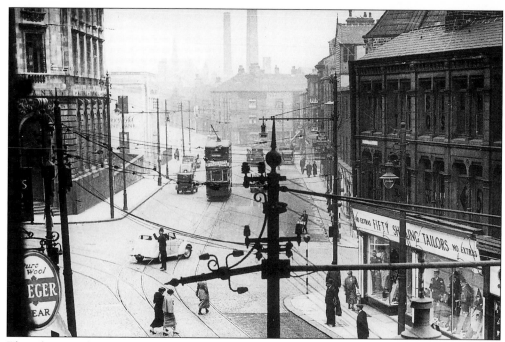

This photograph captures the abundance of street lamps, tram standards and telegraph poles that were once in Waterhouse Street.

THE
Archive Photographs
SERIES

AROUND
HALIFAX

Compiled by

Stephen Gee

CHALFORD

First published 1996
Copyright © Stephen Gee, 1996

The Chalford Publishing Company
St Mary's Mill, Chalford,
Stroud, Gloucestershire, GL6 8NX

ISBN 0 7524 0396 6

Typesetting and origination by
The Chalford Publishing Company
Printed in Great Britain by
Redwood Books, Trowbridge

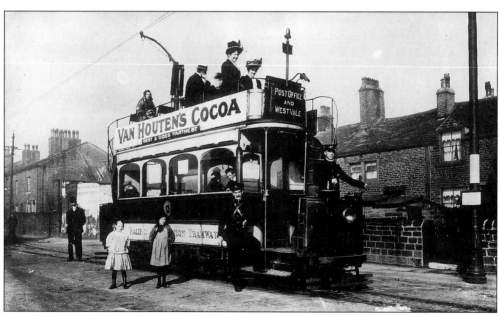

Built by Milnes of Birkenhead, pictured here is one of the Halifax Corporation tramcars that were purchased in 1900. Tramcar No.55 waits on Gibbet Street at Highroad Well in 1905 before resuming its journey to the post office and West Vale. The route to West Vale opened on 2 August 1905 after plans to install a tram lift down Salterhebble Hill had been abandoned.

Contents

Acknowledgements

I would like to thank all the photographers, both professional and amateur, who over the years have helped to record the many events and changes within the Parish of Halifax and acknowledge that without their work this book would not have been possible.
I would also like to extend thanks to the staff at the Calderdale Central Library and to those at the *Evening Courier*, Halifax, both past and present.

During thirty years of collecting historical material on Halifax Parish many people have donated items to my collection.
I would like to thank all those people and hope that they gain some satisfaction from seeing their material used in this manner, knowing that others will also benefit from their generosity.

I would also like to thank the many individuals who have helped me with the book and, in particular, those who assisted with the research. Towards this I express a special acknowledgement to Joyce, Michael, Helen, Christopher and Linda.

Introduction

The Ancient Parish of Halifax is one of the largest in the country yet, despite its size, historians have long stressed that Halifax, to a large extent, has remained detached from the major events or 'episodes' that have shaped the overall history of the country.

In 1816, T.D. Whitaker wrote of the parish in his *Loidis and Elmete*, 'the antiquary who looks through this extensive district for those appearances which most delight him will be disappointed. In a tract of more than 120 square miles, there exists not the remnants of a castle'. The theme continued and in 1920, T.W. Hanson in his *Story of Old Halifax* states that the tourist will find neither walled city, castle, ruined abbey or ancient battlefield and refers also to the town escaping, in the Middle Ages, much of the frightfulness of the civil wars.

The reason for this is attributed to the location of the parish, being surrounded by the Pennine hills and its general inaccessibility until modern forms of communication and transport came along. Until then the easiest route between north and south was on the flat plains and, as Hanson alludes, kings of old would not march their armies through Halifax, and its hills, to do battle.

Yet, looking at a general history of the parish there have been numerous discoveries from prehistoric times, including flints and stone implements, cinerary urns, stone and earth circles. These latter discoveries are, like the Ladstone Rock at Norland, considered to be Druidical remains.

The Roman period has left much that stimulated debate regarding road building and possible settlements or encampments within the parish. Many discoveries have also been made from this era including numerous coins and bricks and, most importantly, a votive altar dug up at Thick Hollins, Greetland in 1597.

Much discussion has also taken place regarding the Saxon era and the siting

of settlements and possible entrenchments and fortifications in the district. The historian John Watson in his *History and Antiquities of Halifax* (1775), refers to the large hill overlooking Ripponden known as Coneygarth and suggests that that this was derived from the Anglo-Saxon 'cynig', a king, and the British, 'garth' a mountain. From this, and supporting evidence, he makes the inference that a Saxon king and his forces were once encamped there.

The Norman era brought with it the earliest period of written and authenticated information relating to the parish. Many records exist from this period, in particular the court-rolls of the Earls of Warren who were granted the Manor of Wakefield, which included the greater part of the Parish of Halifax, by William the Conqueror.

Since that time events in the history of the parish are well documented. The famous 'Eland Fued', resulting in the death of Sir John Eland and the subsequent extinction of the 'Eland' family. The infamous Halifax Gibbet Law, where thieves were beheaded for stealing items over 'thirteen half pence'. The battles, or skirmishes, that occured around this area and the part local people played in the Civil War have been well covered by past historians. Following on from the Civil War there were devastating outbreaks or 'visitations' of the plague to the district.

However, history is not just about castles, ruined abbeys or ancient battlefields, it is about evolution and the changes that happen in everyday life; the changes seen by ordinary people in the way they spend their time at work and at leisure, the changing modes of transport and communication they use and the changes that occur to the appearance of towns, villages and surrounding landscape.

Halifax owes much of its modern heritage to its industrial past. In 1473, during the 'domestic system', Halifax produced more cloth than any other parish in the West Riding and remained at the head of the county's cloth industry for over 300 years.

However, if history is about change then the last century has seen more than any other. Fortunately, for an account of this time we no longer have to rely solely on the written word, the camera has provided us with pictures that are in themselves historical records of events and scenes that are long gone.

One feels that Halifax has been extremely fortunate in this respect when considering the excellent work of such professional photographers such as Crossley Westerman of Hebden Bridge and Albert Townend of Elland. Coupled with these were the large numbers of enthusiastic amateurs who often produced photographs of high quality which have come down to us and perhaps Henry Sutcliffe, who captured the changes at Heptonstall, is a prime example of these. Examples of the work of these three photographers, along with many others, are contained within this book presenting a pictorial record of some of the day to day changes and special events that have helped shape the history of the Parish of Halifax in the last 100 years.

Stephen Gee, Ripponden 1996

One

Halifax Town Centre

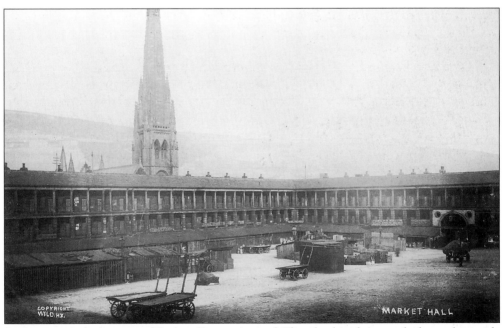

Looking towards the spire of Square Congregational Church, this photograph shows the inside of the Halifax Piece Hall when it operated as a wholesale fish, fruit and vegetable market. The Piece Hall was restored in the early 1970s after being listed by the Department of the Environment as a Grade One building of historical and architectural interest. The Piece Hall was reopened on 3 July 1976 by the Mayor of Calderdale, Councillor Mrs M.R. Mitchell.

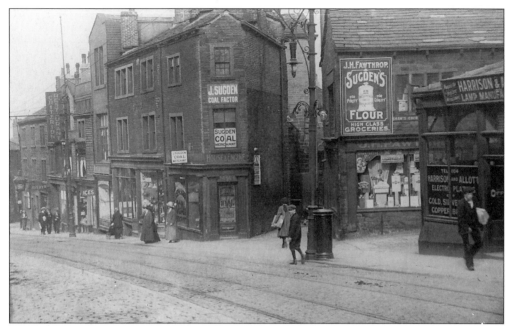

The grocers shop of J.H. Fawthrop, 35 Bull Green, is on the corner of Little Lane and at the entrance to Shaw's Court, in this picture, that looks down from King Cross Street. The sign for the Criterion Restaurant can be seen further down Bull Green. These properties were demolished as part of the Bull Green development scheme 1904-1932.

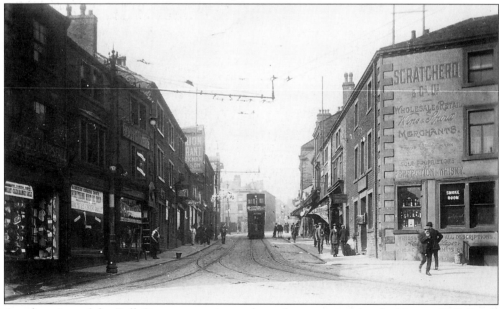

Another view of the Bull Green properties at about the same time but looking up Bull Green towards King Cross Street. In the window of Peter Horsfall's is a sign stating 'Premises Coming Down, Great Clearance Sale'. The shop immediately above is vacant, perhaps having had more success, their sign states 'Premises Coming Down, Everything Must Be Sold, Regardless of Cost'. The photograph was taken in 1914 and the properties were demolished the following year.

This relatively rare photograph shows the Parcel Department, of the Halifax Corporation Tramways which was located at Back Commercial Street. The premises have recently been incorporated into the extension to Harvey's Department Store.

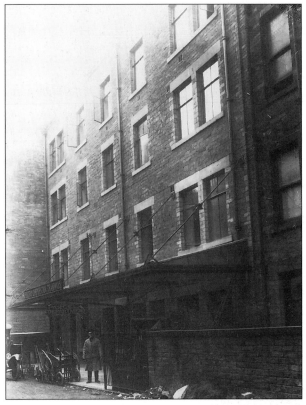

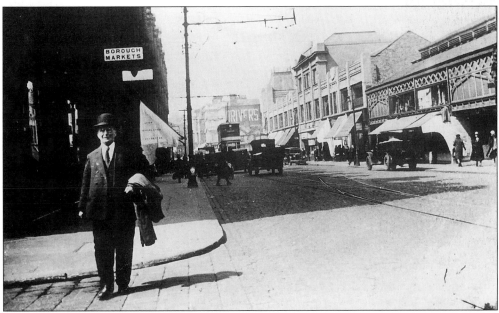

Having just passed the Borough Market, this smart looking gentleman is here crossing the junction of Market Street and Albion Street. Readers may remember the Lower Market on the right of the picture, or maybe Driver's Market whose sign can be seen in the distance. Apart from his store in Old Market J.S. Driver also had premises in King Cross Road.

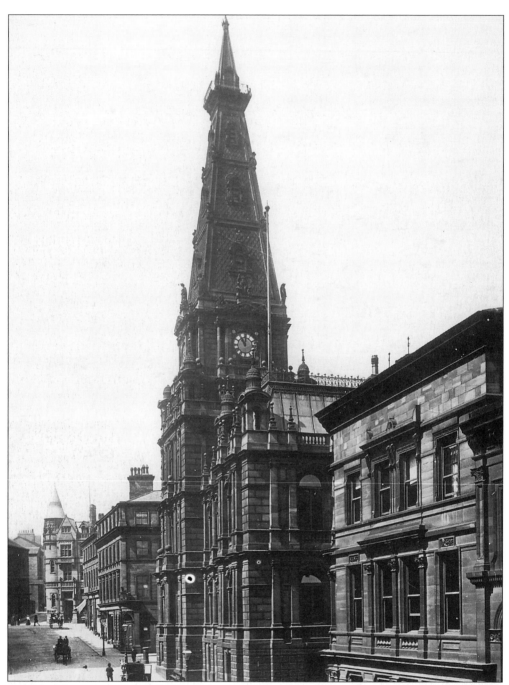

An Edwardian view of Crossley Street and the Halifax Town Hall. The street was laid out as part of John Crossley's improvement scheme prior to the opening of the Town Hall in 1863. Countless numbers of people pass the hall each day but how many stop to admire the fantastic stone-carving, particularly at the higher levels? The sculptor was John Thomas (1813-1862) who also produced the carving on the Buckingham Palace Gates. John Thomas also worked with the architect of the Town Hall, Sir Charles Barry, on perhaps his more famous building, the Houses of Parliament.

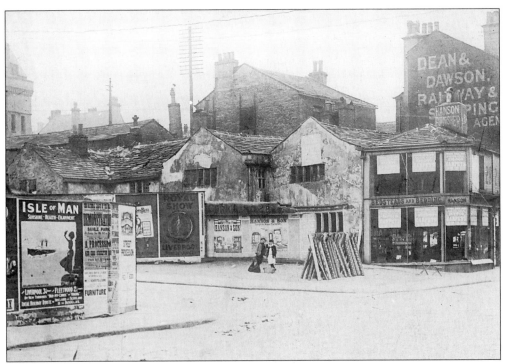

A view showing the old properties at South Place which was located at the bottom of what is now, King Edward Street. The Arcade Royale, now incorporated into the Halifax branch of the Co-operative Retail Services, opened on this site in 1912.

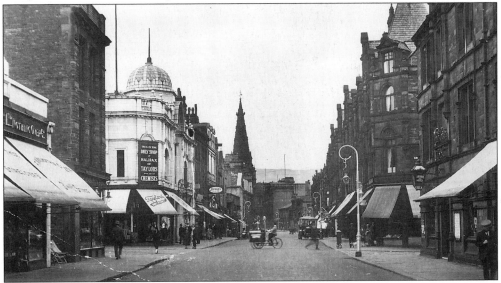

A delivery bike crosses the junction of Southgate, King Edward Street and Albion Street; unfortunately it is travelling too fast for the camera to capture the business name written on it. The sign at the bottom of Arcade Royale however, can be clearly seen: 'This is the only Shop in Halifax of Taylors' Drug Co. Ltd Chemists'. The canopies and sign immediately on the left are those of F.W. Woolworth and Company Ltd advertising 'Nothing over 6d'. The lamp standards are interesting; perhaps they could be described as 'art deco'?

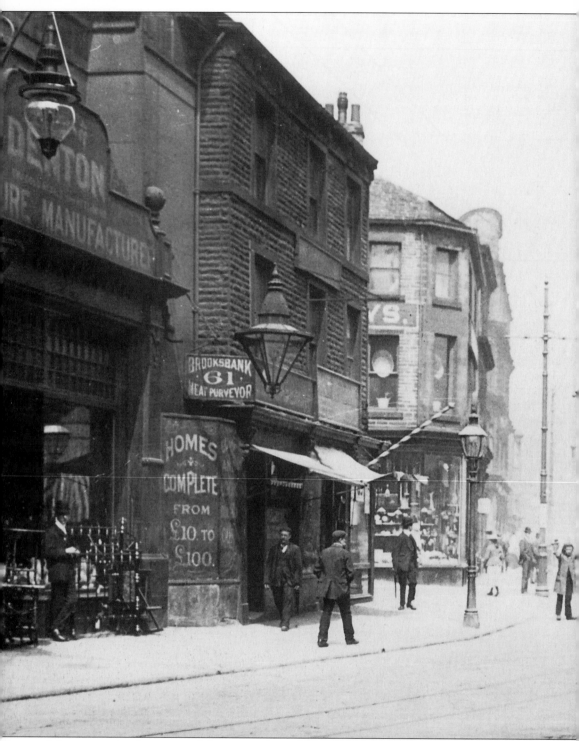

A busy street in the centre of the town. A similiar view today would show a vastly different scene. This photograph is of Northgate looking towards North Bridge and virtually all the buildings in the picture have now been demolished. Portland Street leads off to the left and the

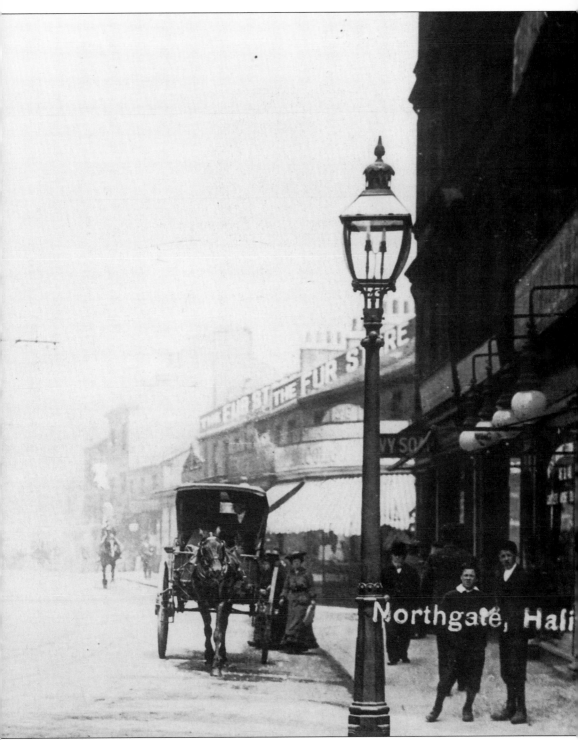

site of Walter Denton's furniture shop is now the bottom corner of the Broad Street car park. On the right is the renowned store of furrier, James Wadsworth, which was established in 1857, later moved to premises in Silver Street and closed in 1979.

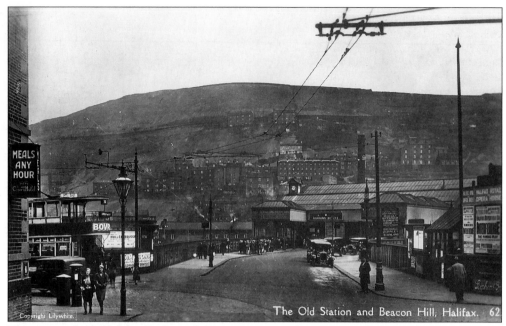

The approach to Halifax Railway Station was opened in 1886 and is seen here against the backdrop of Beacon Hill. A tramcar waits on the left, whilst on the right a sign, perhaps a little ominous for the tramway system, states 'Halifax Corporation and Railway Services, Stand Here for Buses to Heptonstall, Midgley and Ripponden'.

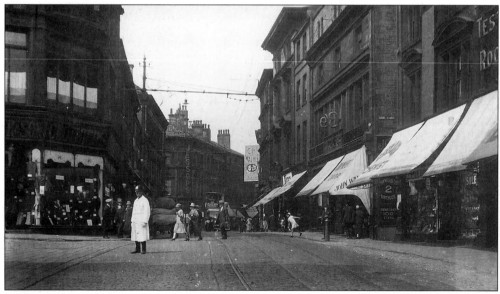

Looking along Northgate the policeman is standing at the junction with Old Market. On the left is J. Hepworth and Son, clothiers, whilst a tramcar advertising the Falcon Laundry is passing the ladies outfitter and drapers, C.H. Walker, 'the open store, with a personal service'. The store, on three floors, had seventeen different departments; I wonder if permission would have been granted today for their rather large sign.

The Prescott Fountain was erected in 1884, at Wards End, by Mrs Leigh in memory of her mother, Mrs Prescott of Summerville. Fourteen years later, due to the building of the tramway system, the fountain was moved to King Cross. In 1932, as a result of the increase in traffic in its 'new' location, the fountain was again moved, to Spring Edge. Apart from the four taps for public use the fountain had two large troughs for horses and four smaller troughs for sheep and dogs. The fountain is seen here at the top of Horton Street in front of Ward's Hall.

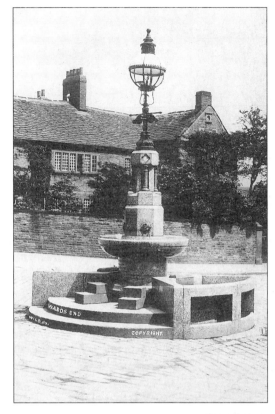

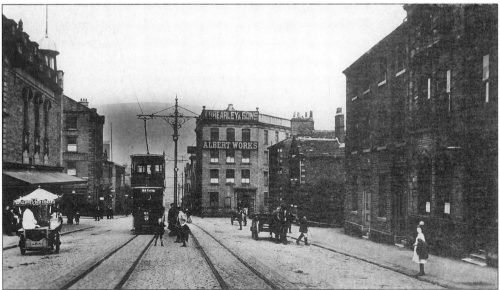

Sutcliffe's ice-cream cart is seen on the left in this view looking down Horton Street. In the centre of the picture is Albert Works, where Joe Brearley and Sons manufactured boots. Like many of the local place names, Horton Street is named after the family of that name. Sir Watts Horton owned thirty-eight acres in the neighbourhood including the site of the Halifax Railway Station.

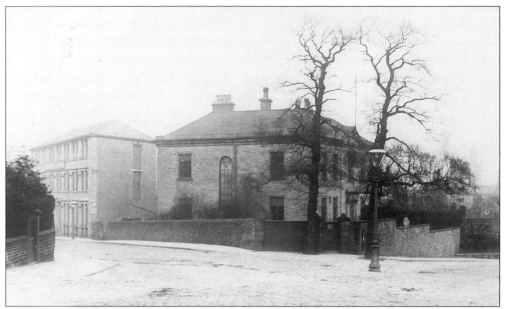

This photograph, from the turn of the century, shows the house originally known as Heatherstone which was purchased by the St John's Lodge in 1895 and became the Masonic Hall. The De Warren Lodge became joint owners in 1901.

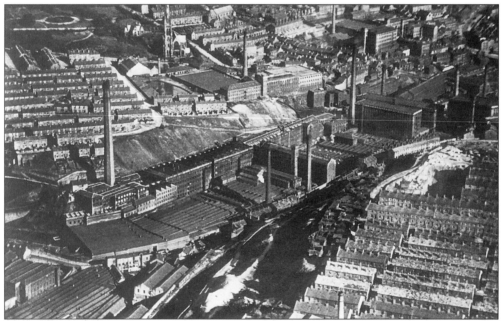

This superb overhead photograph shows the extent of Crossleys Dean Clough Mills. The photograph also illustrates the large number of houses erected to accommodate the workforce of the mills. To the right is Mount Pleasant, where Stannary Quarry can be made out at the end of Temperance Street, Health Street, Freedom Street and Pleasant Street. On the left are the houses at Woodside, immediately above the Mill Pond and Bankfield Mill. To offset what seems to be a wholly industrial scene, Akroyd Park is visible, (top left) and Woodside Baths are situated just above All Soul's Church on Boothtown Road.

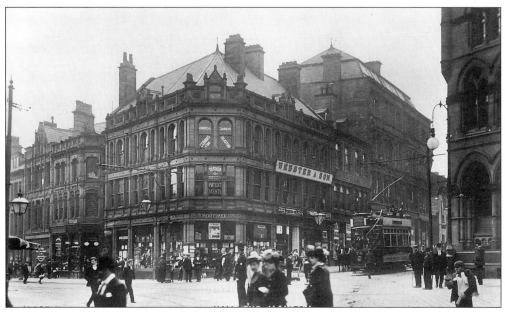

Commercial Chambers faces the photographer in this view of Hall End. Edward Mortimer, stationers, is on the ground floor now occupied by Jowett and Sowry Ltd. The area is named after the Cloth Hall which was built here in about 1700, a predecessor of the present Halifax Piece Hall.

A queue waits for the tram to Bradshaw and Causeway Foot at the bottom of Rawson Street in this photograph which also shows the excellent frontage of the General Post Office. The Post Office was designed by Henry Tanner, architect to the district's Board of Works, and opened on 23 June 1887. Rawson Street, named after the family of that name, was authorised under the 1853 Improvement Act.

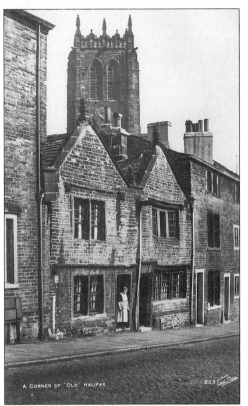

The tower of Halifax Parish Church overlooks these seventeenth-century cottages that stood in Church Street until their demolition in the 1940s. The adjoining properties have also disappeared, having been demolished in the 1960s.

A CORNER OF "OLD" HALIFAX 223

Although now changed beyond recognition, a couple of familiar landmarks help to place this photograph: St Thomas's Church, Claremount and the sign of G. Swift and Sons. However even these have changed. The spire of St Thomas's Church was demolished in 1971 and the sign at Swift's now reads Crawford Swift. Range Lane can be seen in front of Haley Hill Cotton Mills, now the site of a Nissan garage. All the buildings in the foreground have been demolished and replaced by the tower blocks of Haley Court, Ackroyd Court and Range Court.

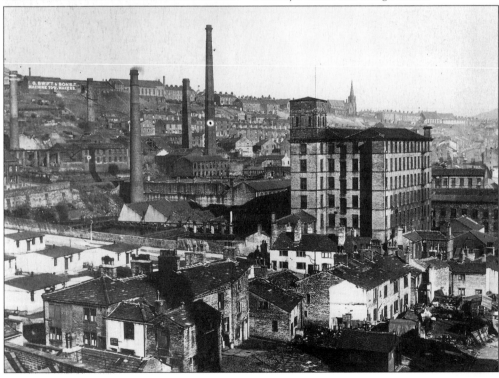

An unusual view showing Barum Hall Meeting Room. A clue to the exact location is Bull Green House, the large building that is just visible on the top left of the picture. Barum House stood at the junction of Harrison Road and Bull Close Lane. This photograph was taken from the solicitor's office of John R. Farrar in 1938, the year that Barum House was demolished.

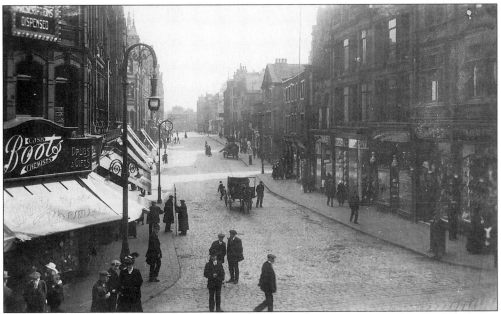

In this view of the Corn Market, Boots cash chemists stands at its junction with Old Market. On the right of the picture are the large premises of Whiteleys, 'The Hat Makers', who were established in 1746. Halifax had numerous shops specialising in headwear known as 'hatters'. Perhaps a closer look at the picture reveals the reason why: everybody but one is wearing some form of hat.

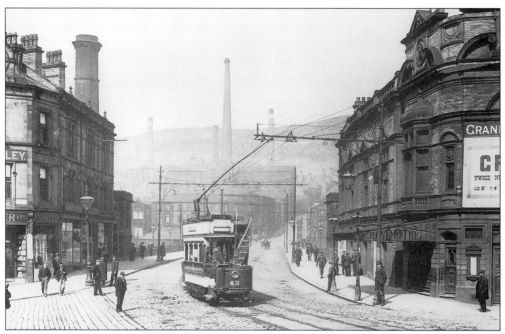

Tramcar No.43 is passing the Grand Theatre in this photograph of North Bridge. The foundation stone for the Grand Theatre was laid on 27 November 1888 by Wilson Barrett; who also opened the theatre on 5 August the following year. The building was demolished in 1957.

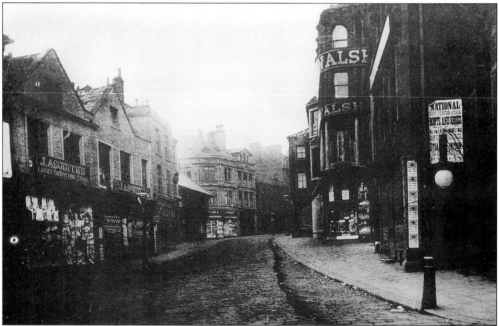

Old Market from its junction with Northgate in the late 1880s. The entrance to the Union Cross Yard is on the right, whilst in the centre of the picture, at No.1 Corn Market, is Dyer's chemist which was also known as the House at the Maypole. This fifteenth-century building was demolished in 1890 under the supervision of John Lister and rebuilt on Leeds Road, overlooking his grounds at Shibden Hall.

Two
Scenes Around Halifax

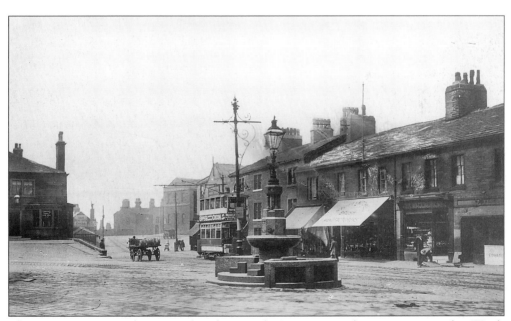

The Prescott Fountain dominates this photograph. Seen in an earlier picture situated at Wards End, it was moved to its location at King Cross in 1898 but due to an increase in traffic was relocated to Spring Edge in 1932. On the left is the Old King Cross Inn, while on Burnley Road are the large premises of James Hoyle and Son, removers, storers and haulage contractors.

This photograph of 1889 shows Caygill's Walk, named after John Caygill, shortly before it was replaced by Skircoat Road which connected the town centre with Huddersfield Road. Just visible in the trees on the right is Shay House, the home of John Caygill who provided the plot of land upon which the Halifax Piece Hall was built and who also donated £840 towards the original building costs of £8,460. The playing field that was established in the grounds of Shay House is now the home of Halifax Town AFC.

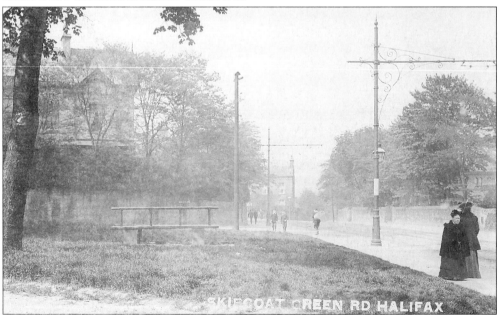

Skircoat Green Road at the junction with Manor Heath Road in 1907. The large house visible through the trees on the left is Holly Bank, once a private residence but now a nursing home. Further towards Halifax, Lyndene is the house in the middle where Skircoat Green Road bears off to the right; Heath Road passes the house on the left.

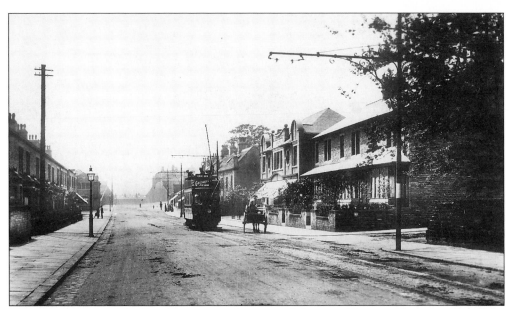

This tramcar is passing the rather ornate frontage of the new Skircoat Green branch of the Halifax Industrial Society Ltd. The original branch opened on 7 April 1862 in premises now known as Chancery Terrace. The name of the premises commemorates the society's victory in the Court of Chancery in a dispute with Samuel Rhodes about legal rights in Skircoat Green.

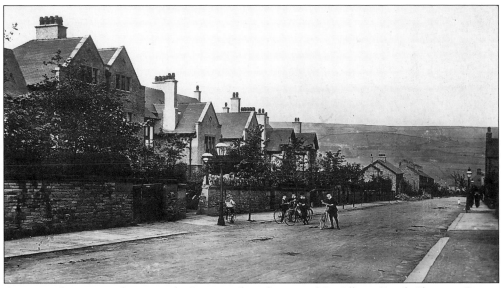

A group of young cyclists outside Greenroyd at the top of St Albans Road, Skircoat Green. With the exception of the trees having matured, little else has changed since the photograph was taken in about 1913. A closer look reveals that the walls outside the houses Greenmore and Belvoir were still being built.

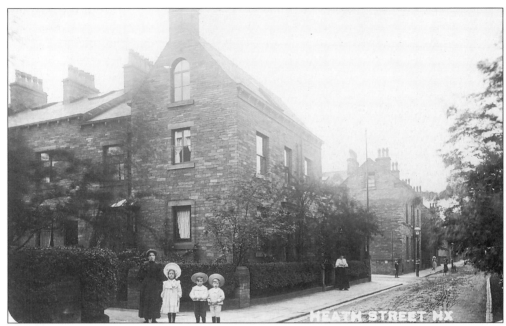

This image is characteristic of the work of photographer J. Hodgson of Cleckheaton, whose hallmark was exceptional photographs in terms of quality and animation. Around 1907 he took numerous photographs of the streets and houses of the area and usually featured groups of people posing for the camera. Taken on Heath Street looking towards the Royal Halifax Infirmary, this group, in boaters and their Sunday best, are at the bottom of Third Avenue.

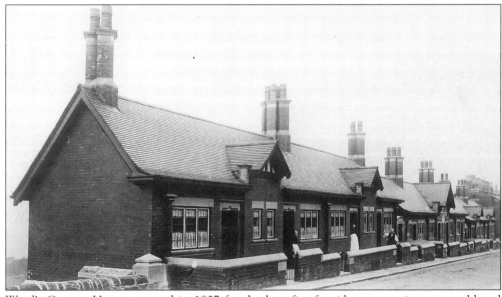

Ward's Cottage Homes, opened in 1907 for the benefit of residents over sixty years old and unable to work. The twenty-four cottages were built and endowed by the Mayor of Halifax, Richard Dearden Ward. The cottages, now demolished, overlooked the Calder Valley from their position on Washer Lane.

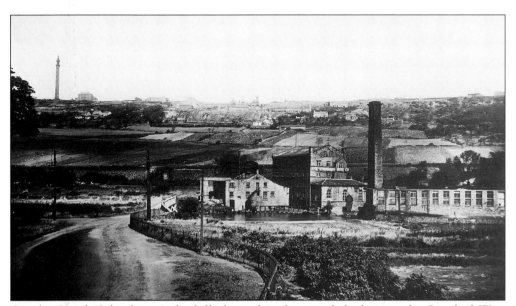

Crossley Heath School is on the hillside in this photograph looking at the Standard Wire Company, Sterne Mills. Missing from a similar picture taken today would be the Halifax Building Society Data Centre which opened on Wakefield Road in 1989.

West House, King Cross Street at the corner of People's Park in the 1920s. The premises, now occupied by FKI plc, were for many years the education offices after the department moved there in 1914.

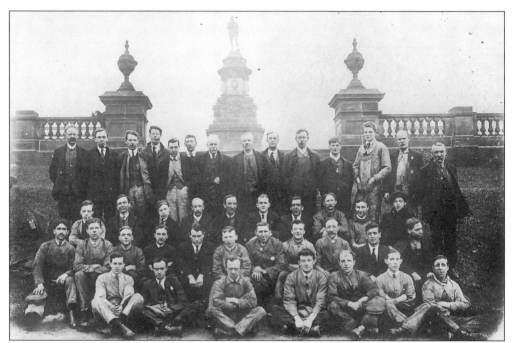

Judging by their expressions, having to pose for this picture brought mixed reactions from the members of this group. The photograph is taken in West View Park with the South African war memorial in the background. Behind the group can be seen a balustrade which stood originally in Town Hall Street East, below the Halifax Town Hall, but which was moved to the park around the turn of the century.

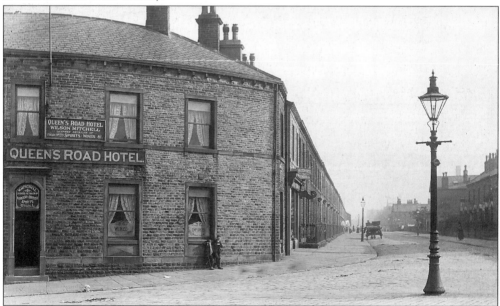

This photograph was taken around 1905, when Wilson Mitchell was the landlord of the Queens Road Hotel. More recently it has been aptly renamed Queens Road End, located as it is at the end of Queens Road. Just around the corner, still on Queens Road, is the sign for Arthur Holdsworth, plumber. This property is now the Queens Road salerooms.

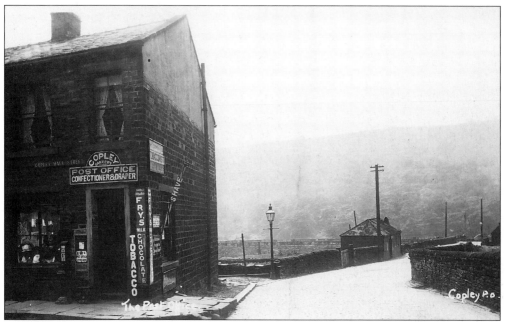

Many post offices these days have what could be called sidelines; this one obviously had many. A close look reveals that not only was the post office at Copley a confectioners and drapers, but a barber's pole, advertising shaves, can be seen attached to the wall on the right hand side. Note also the 1d Nestle chocolate dispenser, apparantly free standing, to the left of the door. The building has since been demolished.

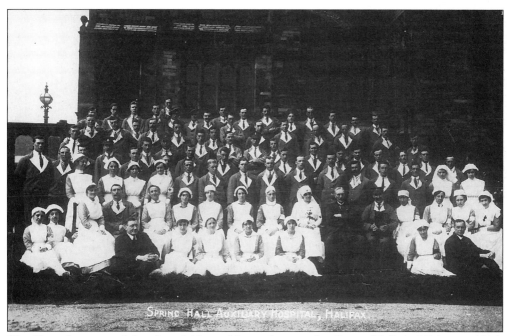

The Convalescent and Auxiliary Military Hospital, opened at Spring Hall on 1 February 1916. The hospital was staffed by War and Voluntary Aid Detachment nurses with the St John's Ambulance Brigade carrying out night duties.

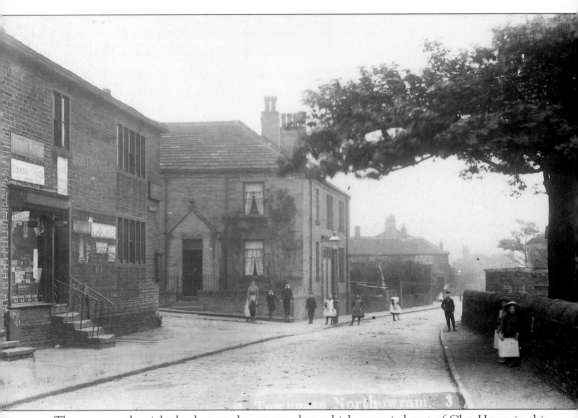

The steps on the right lead up to the grocers shop which occupied part of Clay House in this 1910 photograph of Towngate, Northowram. The steps have since been removed and the property, one of the oldest in Northowram, is again a private residence. The house was built by John Clay in the early seventeenth century. John was the father of William Clay who, in the 1680s, donated the ground for Oliver Heywood to build his chapel. Clay House was later occupied by Joseph Anderton who in the early part of the eighteenth century had consigned to him all the wool for the Northowram district. He would hand out the wool to be combed, spun and woven and on Saturdays, in Anderton Fold (formerly Clay Fold), would collect the finished pieces.

This photograph of 1910, entitled Towngate, Northowram represents a slight misnomer as the photographer was actually looking up Lydgate. In fact, the houses on the right were the end of Towngate until their demolition in 1981. The properties were also known as Haley's Buildings, a reference to their owner at the turn of the century, Miss Hannah Haley, who lived at Savile House. The chimney seen at the intersection of both terraces is that of the butchers Herbert Sunderland and Son, currently run by 'and Son' – Roger Sunderland. The property has been a butchers shop for a long time. One of Roger's elderly customers can still recall Butcher Wade (Samuel), who at night would place a lighted candle in his window to let passing drovers know that he was still open for trade; he would then sit back in his rocking chair awaiting business. Butcher Wade had the shop as long ago as 1905.

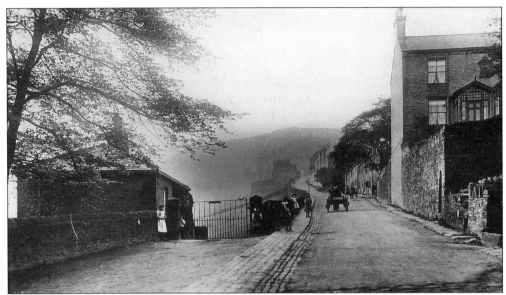

The Old Mission at Salterlee can be seen in the distance of this view of Kell Lane and the glorious valley of Shibden Dale. The date stone inscribed on the buildings on the right, Nos 10 and 12 Kell Lane, bears the date 1885. Salterlee Lodge on the left was demolished after being damaged in the air attack of 14 March 1941. Following the attack twenty six people were temporarily evacuated from their homes. That same night incendiaries also fell in Northowram and Shelf.

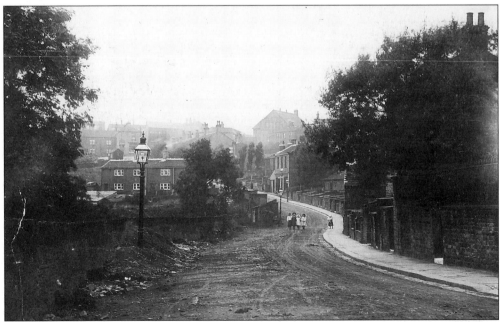

Postmarked 1907, this photograph, taken outside Laburnum Cottage shows a view looking up Brow Lane, Shelf. The Wesleyan chapel in the middle was opened on 18 May 1887; the building cost £1,480.

An excellent window display at
C. Beveridge's shop on the corner of
Ovenden Road and Lentilfield Street,
Ovenden.

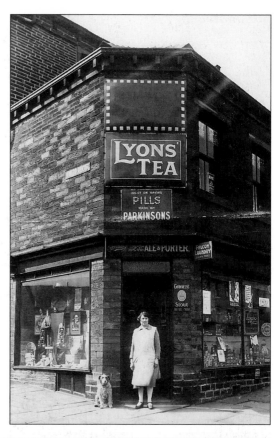

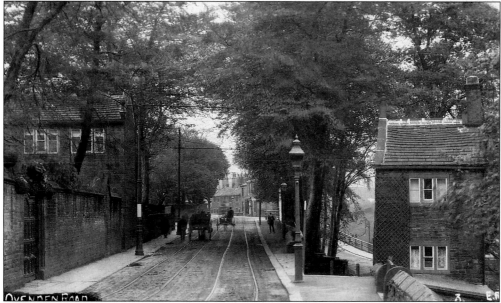

The narrow house on the right of this photograph is The Cottage, Ovenden Road. The path in
front of the house leads to Old Lane and presumably provided a short cut to Ovenden railway
station. Ovenden Hall, built by Joseph Fourness in 1662, is to the left of the picture.

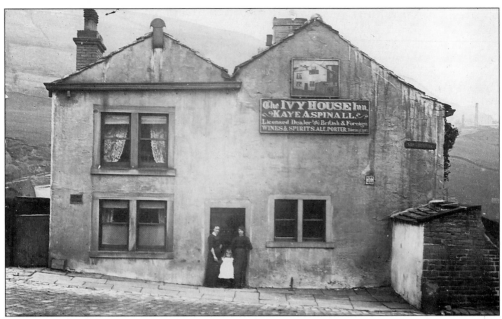

The Ivy House, or Little Moor as it was originally named, was built in 1704 by John Brearcliffe. In *Walker's Directory* of 1845, James Riley, tailor and farmer is mentioned as living at Little Moor. The change of name must therefore have taken place after 1845 but before 1887 when *White's Directory* lists Elijah Lister as farmer and victualler of the Ivy House. The public house stands at the end of Shay Lane, Ovenden.

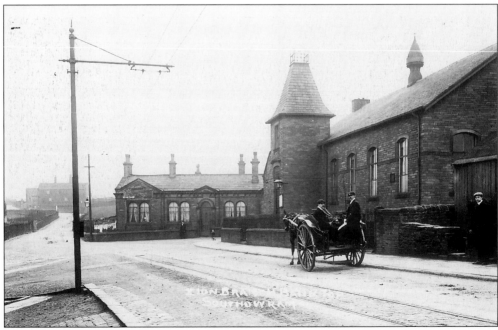

The horse and cart in this photograph of 1910 are outside the Sion Branch, Congregational Sunday School, Southowram. The Sunday School is dated 1888.

Three

Brighouse and Surrounding Areas

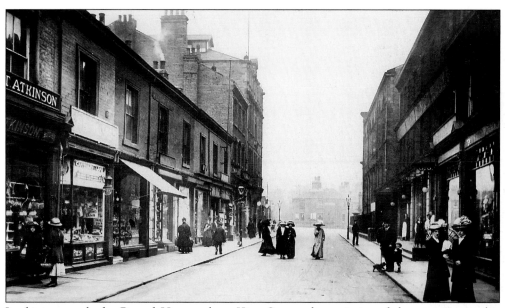

Looking towards the Round House, along King Street, the majority of the premises in this photograph were occupied by the Brighouse District Industrial Society Limited. The Central Stores were opened in 1864, having cost £1,952 which also included the purchase of the land.

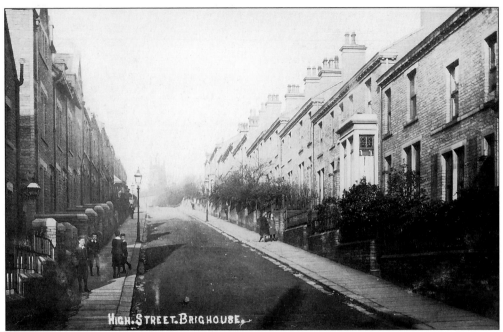

St Martin's Parish Church, Brighouse can be seen at the top of the relatively steep High Street on this postcard sent in 1906.

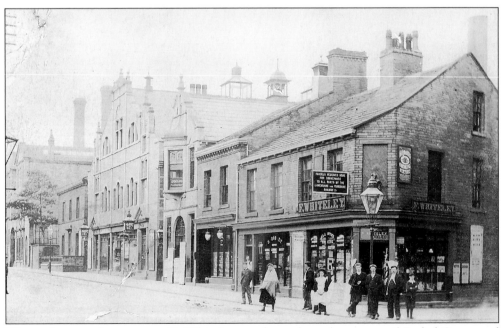

The stationer and newsagent, F. Whiteley was located on the corner of Bethel Street and Huddersfield Road. Note the statue looking over the top of the lamp on the corner. Further up Huddersfield Road is the Albert Hall which was completed in 1899 at a cost of £3,951. In 1972 the hall, then operating as a cinema, closed and was re-opened as a bingo and social club.

It is presumed that those standing on the steps of the shop are Miss Ann Briggs and her assistants. Miss Briggs ran her fancy drapers for many years from the premises at No.23 Lightcliffe Road, Brighouse. The property, more recently a fruit and vegetable shop, is now vacant.

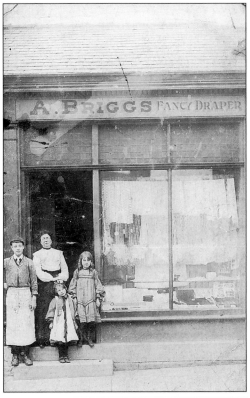

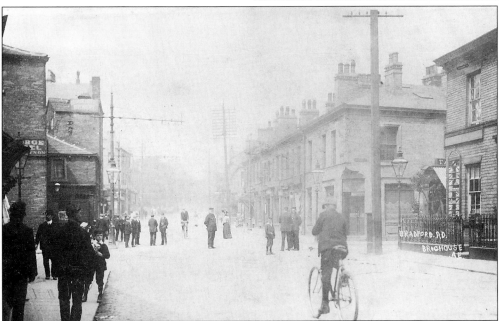

The tram terminus for the Halifax to Brighouse route was originally located at George Corner, Brighouse. The tramway service reached George Corner with the official opening of the route on 26 February 1904 and ran for twenty seven years until the line ceased in May 1931. The sign for the George Hotel Brewery can be seen on the building on the left.

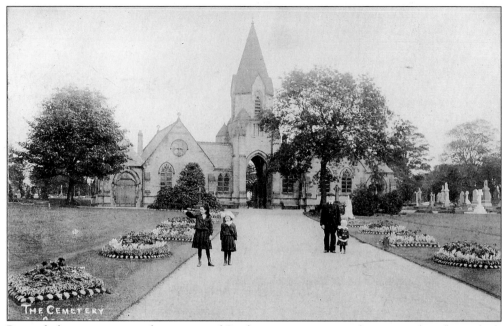

Particularly interesting in this picture of Brighouse cemetery are the immaculate flower beds and lawns lining both sides of the path leading to the cemetery chapel. The chapel was designed by William Gray and the gardens laid out by local nurseryman, Lister Kershaw. The cemetery was consecrated by the Bishop of Ripon in 1874.

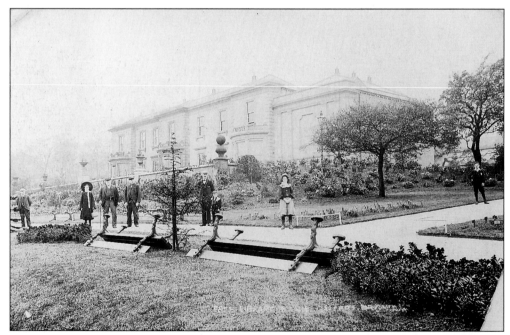

A public subscription was started to celebrate Queen Victoria's Diamond Jubilee in 1897. From this, supplemented by a substantial donation of £1,000 from the Brighouse Co-operative Society, the Rydings estate and mansion were purchased. The latter was turned into a free library and the grounds became a public park, opened by the Marquis of Ripon on 15 June 1898.

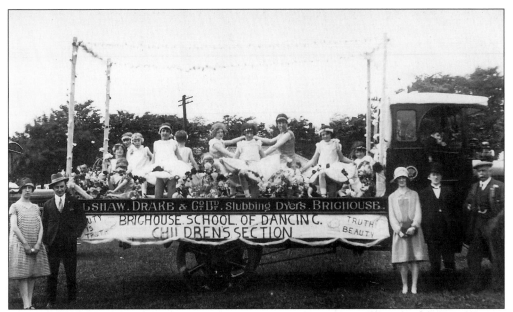

Decorated for the 1927 Brighouse Gala, this float carries the children of Mona Benson's Dancing School. The vehicle belonged to Walshaw, Drake & Company Ltd, top and slubbing dyers, of Rosemary Dye Works, Rastrick.

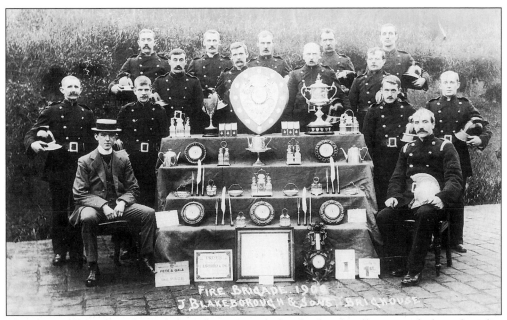

The threat of fire has always been taken seriously by the local mills, particularly earlier this century when, due to the limited fire services of the day, many mills raised their own fire brigade and invested in the purchase of fire appliances. The fire brigade of Joseph Blakeborough & Sons, hydraulic engineers, appears in this 1908 photograph as both very professional and successful, judging by the large number of prizes and awards on display.

This young lad stands proudly next to a cart bearing the name G.H. Jessop, Brighouse. A search of directories of the period has revealed only one G. Jessop (George), a solicitor in Brighouse. Perhaps this young chap is a relative.

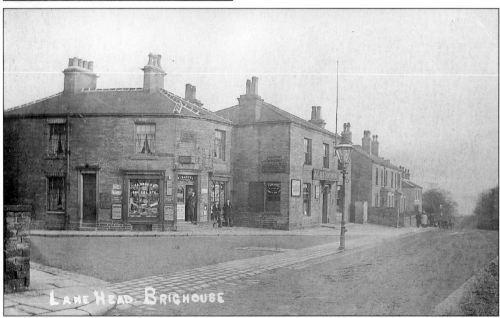

Just above the Albion Inn is Lane Head Post Office at the top of Waterloo Road, Brighouse. The Post Office is still operating from these premises ninety years after this photograph was taken. It was at Lane Head in 1353 that Sir John Eland was killed in a revenge attack by followers of Earl De Lacy during the now renowned 'Elland Feud'.

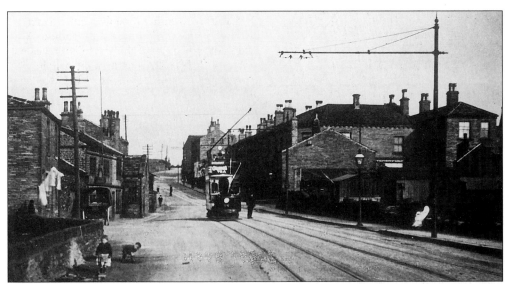

Advertising Collinson's Tea, this tramcar is beside the Dusty Miller Inn, at Hove Edge. The tramway service to Hove Edge commenced on 29 June 1903 and ceased operation on 30 September 1933. The houses to the right, forming Mason Terrace, were built in 1876.

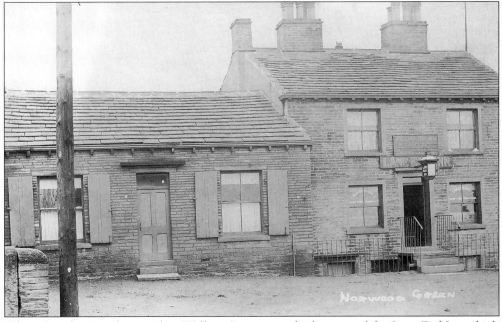

When this photograph was taken William Brown was the licensee of the Lane End Inn which was located at the end of Sowden Lane, Norwood Green. The inn, now a private residence called the Three Chimneys, closed in 1955. The shuttered building to the left is St George's Church Hall.

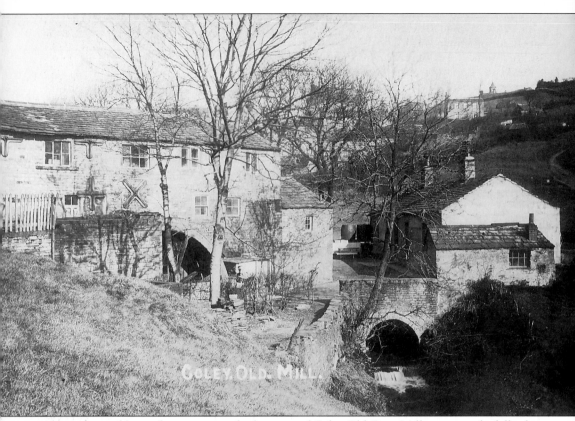

COLEY OLD MILL.

Now changed beyond recognition, the location of Coley Old Corn Mill is extremely difficult to find despite the location of the Ellis Jubilee Clock Tower on top of the hill in this photograph. Today nothing of the mill exists except a few scattered remains and some stone walls: a great historical loss for the district. The mill, mentioned in documents over 430 years ago, used to be referred to as the 'T'Wheel Hoile', due to it being run by the large water wheel visible in the picture. The Coley Mill Inn on the right, which also took on this local name, was granted its license in 1830 by the Duke of Wellington, then Prime Minister, along with 30,000 other beer licenses issued throughout the country that year. The building, although much deteriorated, still stands and can be located in a field below Underhill Farm.

The chimney of Woods Mill appears amongst the clouds in this rather striking scene of Hipperholme. Joseph Wood and Sons Ltd, worsted spinners, operated in Hipperholme for over one hundred years before closing in 1958.

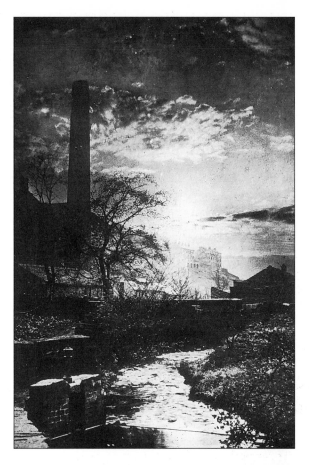

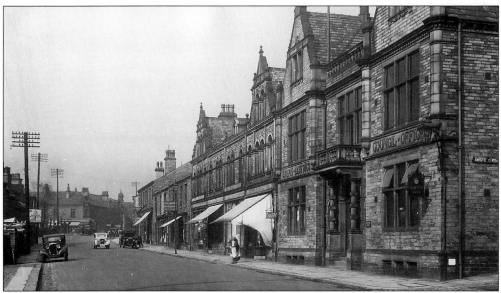

The Leeds to Whitehall Road opened in 1833. Situated on the right in this view along Whitehall Road, Hipperholme, are the council offices which were opened on 2 August 1899.

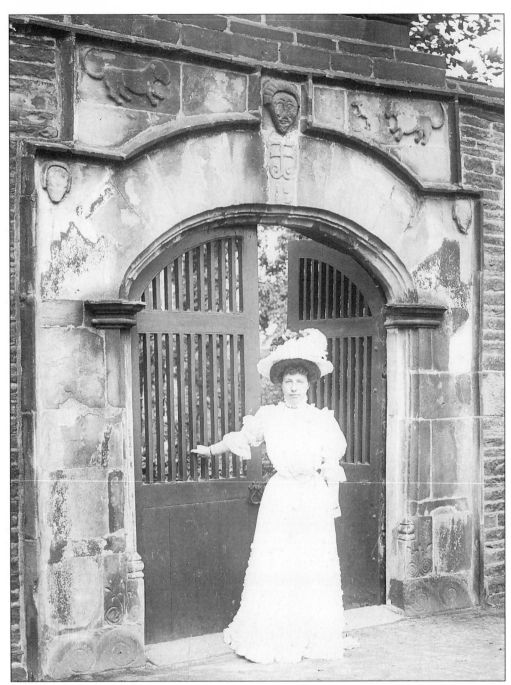

Photographed in 1908, Alice Langdale Mortimer Sunderland is seen here posing in the old gateway to Coley Hall. The gateway bears the date 1649. Richard Sunderland, of High Sunderland, bought the Coley estates in 1572. In 1654 Langdale Sunderland sold the hall to William Horton in a transaction worth £2,200. The sale was to raise money against the heavy fine imposed on him by Parliament for fighting on the Royalist side in the Civil War. However, in 1775, the hall was again in the possession of the Sunderland family when it was purchased by Joseph Sunderland of Elland.

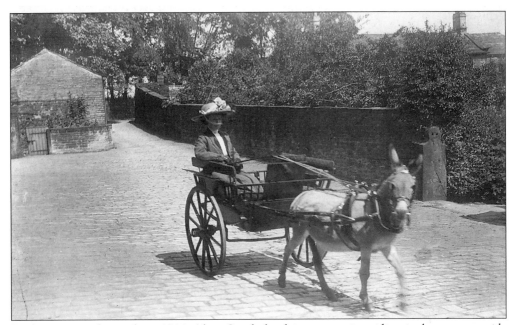

In this picture dating from 1911 Alice Sunderland is seen again, riding in her trap outside another entrance to Coley Hall. Coley Walks Farm is in the trees to the right.

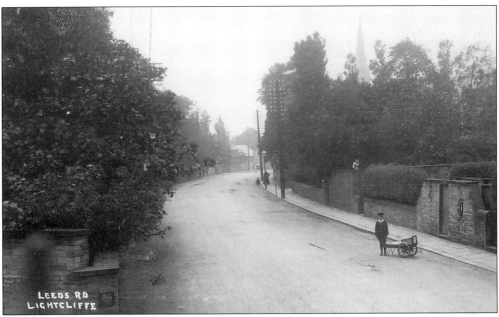

LEEDS RD
LIGHTCLIFFE

A tranquil scene which if recorded today, unless the photographer felt like getting up in the early hours, would show a stark contrast. The delivery boy is standing in Leeds Road, Lightcliffe, now one of the busiest of local roads linking Halifax to Leeds and the M62 motorway. A small girl can be seen sitting on the wall of Whitehall Villas.

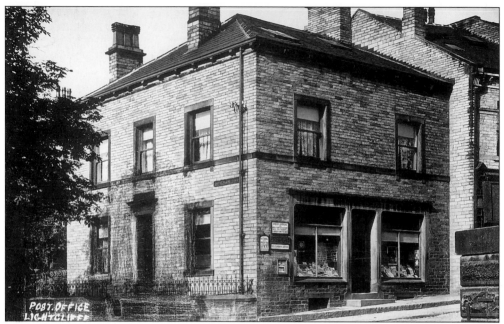

The post box on the wall of Lightcliffe Post Office carries the initials VR (*Victoria Regina*) on this postcard dated 1906. It is believed that the original intention for the building was for a hotel to support the Lightcliffe Railway Station which was immediately opposite on a site now occupied by Park Close.

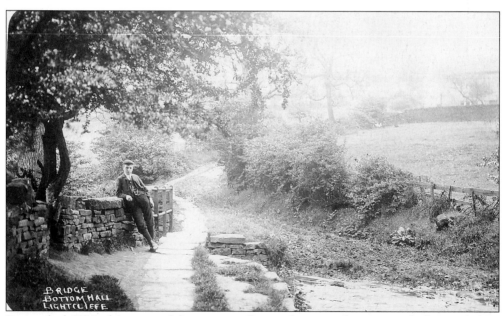

Postmarked 1906, this postcard features a well turned out gentleman in a fairly nonchalent pose, by the bridge at Bottom Hall, Lightcliffe. Note the shine on the clogs.

Four
Elland and Surrounding Areas

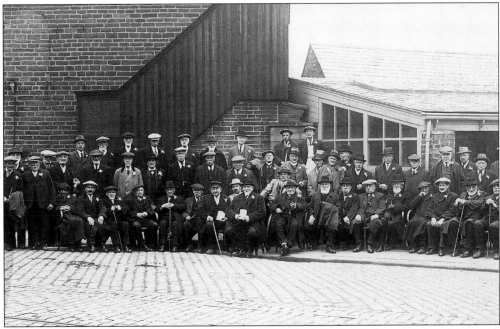

Many districts had what were known as 'Old Mens' Parliaments' where local and national topics would be discussed by the gentlemen of the area. These gentlemen are gathered for the opening of Elland's 'Pinfold' Parliament, pinfold referring to the area which was once used for enclosing cattle.

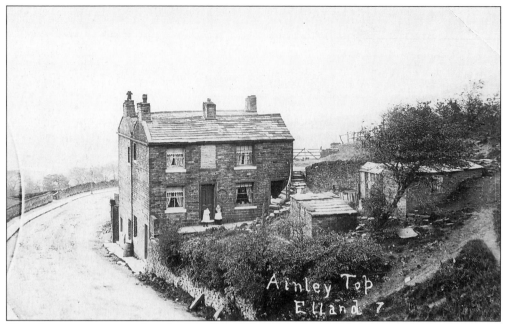

These houses were situated on the sharp bend near the 'summit' of Ainley Top. The photograph is taken looking towards Elland from the point now crossed by the M62 motorway.

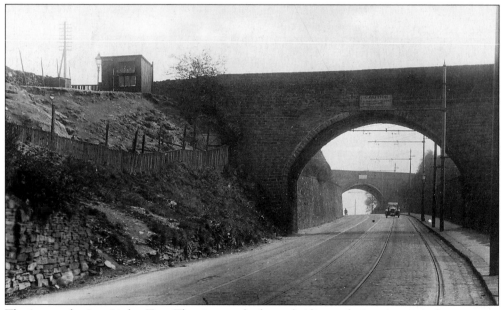

The 'two arches' at Ainley Top. The sign on the lower bridge reads, 'caution, it is dangerous to touch the trolley wires, passengers to remain seated'. Trolleybuses replaced the tramway to West Vale in 1939.

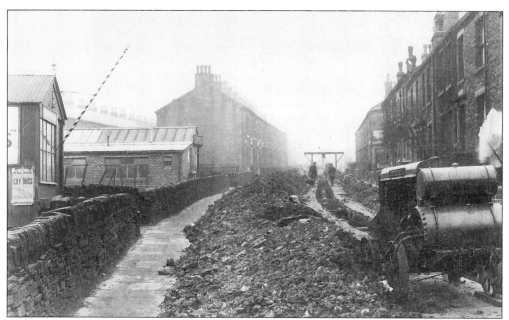

Digging up roads is obviously not just a modern phenomenon! Taken in November 1927 this photograph shows the Ryburn pipe-line being laid in Catherine Street, Elland.

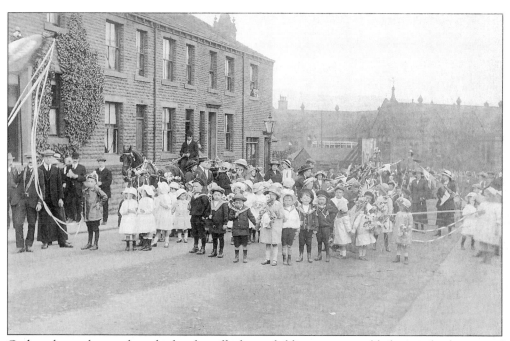

Gathered together and ready for the off, these children are assembled near the bottom of Catherine Street, Elland. Presumably the photograph was taken prior to one of the many carnival processions that the town has witnessed over the years. The dome of the Town Hall clock can be seen above the bottom house. A more recent picture would also show the tower of St Paul's Church, now the Southgate Methodist Church, which was built in 1914.

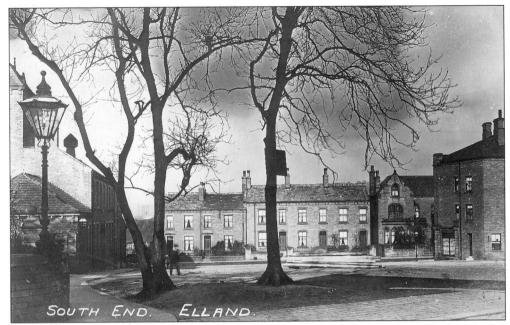

An early view of the 'square', Elland. The Victoria Baths, along with a suite of Turkish baths, were opened on part of this site on 22 November 1902. James Jackson, tailor and outfitter, occupies part of the Town Hall buildings on the right, now a hair and beauty salon. The fire station sign can be seen on the premises on the left.

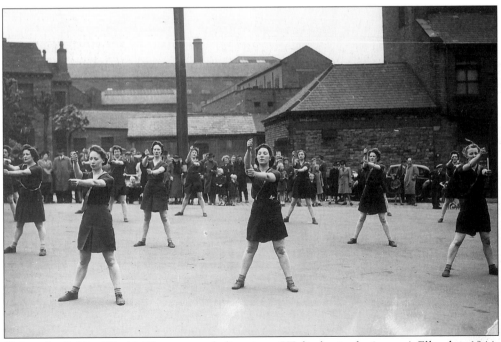

'Salute the Soldier Week'. These young ladies give a PT display in the 'square', Elland, in 1944.

St Mary's Church, Elland, was floodlit in 1935 to celebrate King George V and Queen Mary's Silver Jubilee. The church porch was built in 1696 and the tower, well lit in this view, was built in 1490.

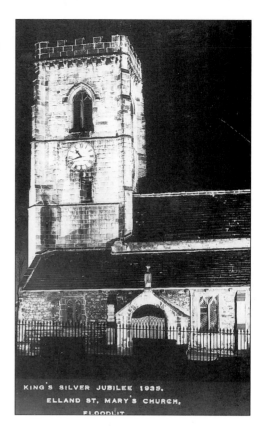

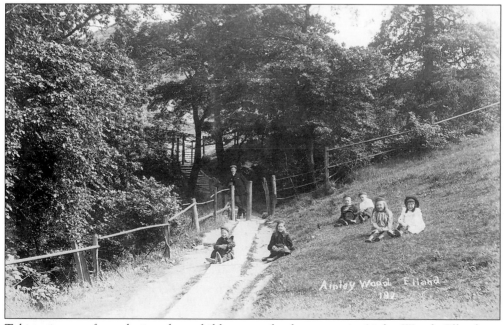

Taking time out from playing, these children pose for the camera in Ainley Woods, Elland.

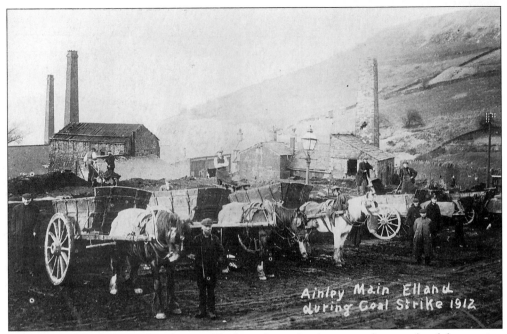

Ainley Main Elland during Coal Strike 1912

The effect of the 1912 coal strike was felt throughout the district with many local firms going onto short time or having to serve notice on their employees. Elland was perhaps fortunate in comparison to other towns when a coal substitute, copperas shale, was discovered around the Ainley area. Hundreds of tons of the shale were carted away to local mills from the Ainley Main helping to reduce the overall effect and hardship that the strike brought to the region.

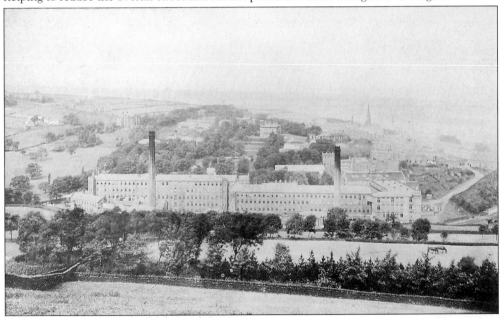

The full extent of the Brookroyd Mills is evident in this photograph of Holywell Green. John Shaw started his carding mill at Brook Mill in 1776. In 1806 an extension was added to the original mill which by then was known as Brookroyd. The spire of Holywell Green Congregational Church can be clearly seen; the church was built by the Shaw family in 1868.

On route to Highroad Well, tramcar No.60 is passing the Station Hotel at the top of Station Road, Holywell Green. The line to Stainland opened on 14 May 1921 and closed thirteen years later in 1934.

A pleasant view of Bowling Green, Stainland looking towards the High Street. The property, immediately behind the young ladies is Well Royd which was built in 1762.

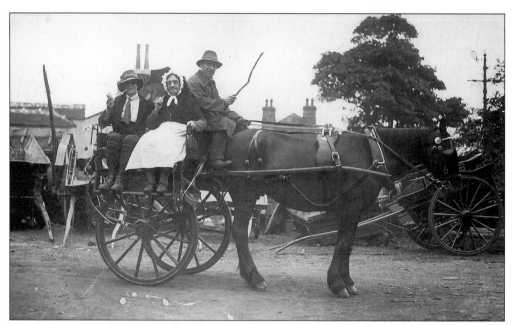

An Austrian scene? Not quite; the photograph is actually taken in the yard of what is now the Outlane Engineering Company on New Hey Road. The tram standard on the right, through the trees, is for the Huddersfield Corporation Tramway to Outlane. The Outlane terminus was the highest point reached by the Huddersfield system.

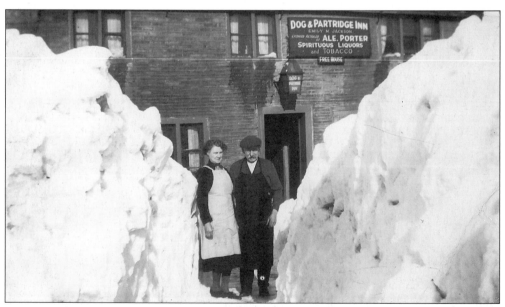

In 1940 and 1947 the district ground to a halt following heavy snow falls. The outer areas, such as Sowood, bore the brunt of the bad weather and resembled something more in keeping with Arctic regions. In this photograph we see the cutting made from the snow drifts to ensure access was retained to the much needed refreshments at the Dog & Partridge Inn.

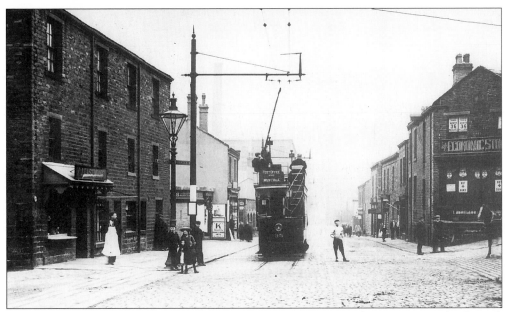

Tramcar No.39 stands outside the building now occupied by The Shears Inn, Stainland Road, West Vale. John Eastwood ran his butchers shop from the junction with Saddleworth Road. Opposite, the Economic Stores can be seen occupying Prospect Place which was built in 1869.

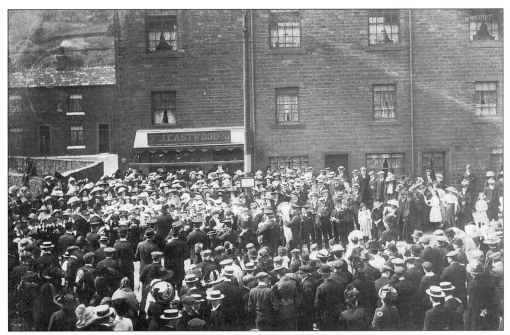

The butchers shop of John Eastwood features again in this postcard dated 12 July 1912. Judging from the dress of those assembled and the band that is playing, the picture is likely to be of that year's Whitsuntide gathering.

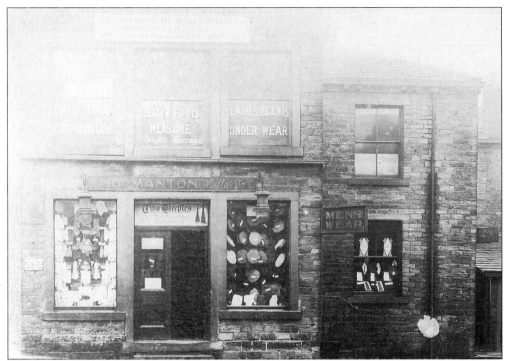

Now a bakery, the sign at the top of this building at the end of Victoria Street makes interesting reading: 'the room where the Wesleyan church commenced fifty years ago being the first preaching place in West Vale'. The sign above the door of Normanton's shop is also perhaps worth noting, 'Two Steeples, Trustworthy Underwear'; well, one can never be too careful!

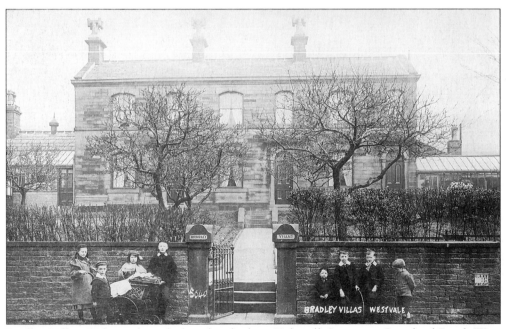

Bradley Villas are located just before the climb to Holywell Green, on Stainland Road, West Vale. Note the unusual chimney pots which are still there today.

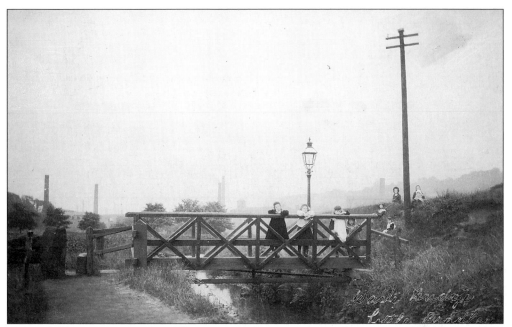

These children are pictured on the Waste Bridge at Little Bradley, West Vale. Also note the children at the side of the brook in this postcard which was sent from Halifax in 1906.

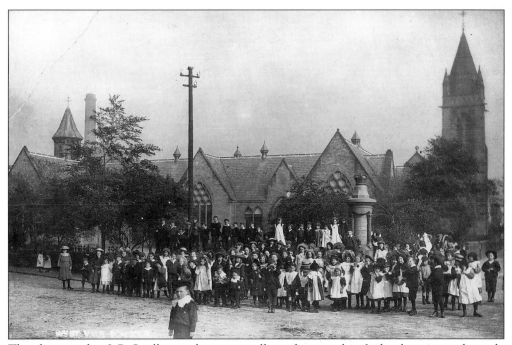

The photographer J.C. Swallow took some excellent photographs of school groups in the early years of this century. Taken around 1904, these well turned out children are pictured in front of the West Vale Board School.

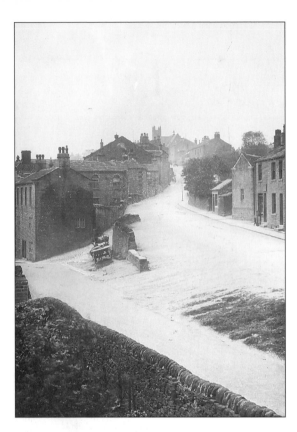

Looking up Rochdale Road,
St Thomas's church is the highest
point in this view of Greetland.
Sunnybank Road leads off to the left
where two cows can be seen standing
next to a cart.

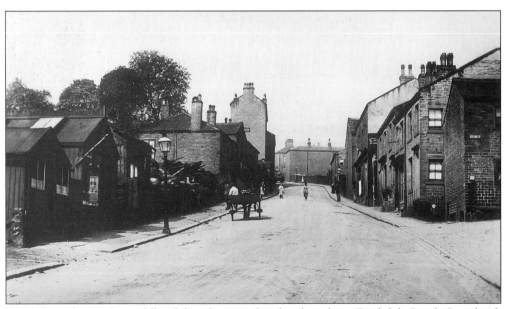

The lady cyclist in the middle of this photograph is heading down Rochdale Road, Greetland.
A barber's pole is attached to one of the wooden huts on the left, opposite Road End.

Five

Hebden Bridge
and the Calder Valley

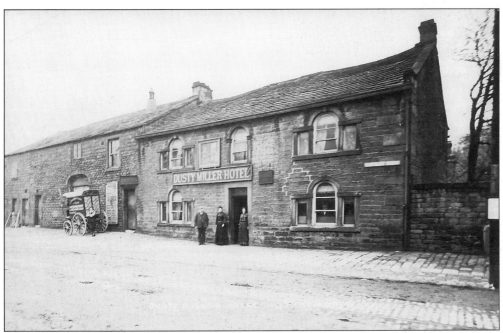

The Dusty Miller Hotel at Mytholmroyd was once the resort of the infamous Cragg Vale Coiners. It was here, following the arrest of their leader David Hartley at the Old Cock, that the coiners plotted the murder of excise man William Deighton. 'King David' was subsequently hanged at Tyburn near York on 28 April 1770; his gravestone can be seen in the graveyard at Heptonstall. Robert Thomas and Matthew Normanton, Deighton's murderers, were also hung at York, their bodies later being suspended in chains on the top of Beacon Hill with their arms pointing to the scene of the murder.

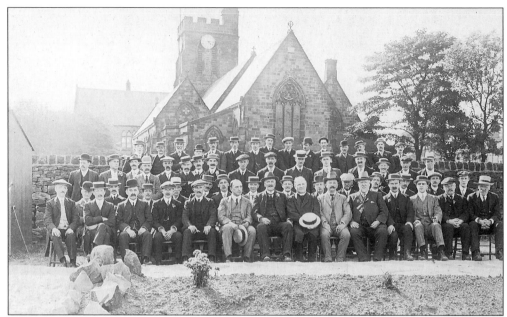

This group of fine gentlemen are lined up overlooking the Bowling Green, next to St Michael's church, Mytholmroyd. A fine display of headwear is also on show. In the middle at the front the Rev. Thomas Metcalfe is holding his boater on his knee. Rev. Metcalfe was vicar of the parish from 1906 to 1924.

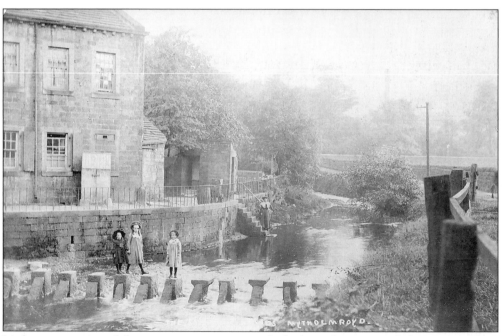

Little now remains of the stepping stones upon which these three young ladies are standing. The stones, now replaced by a footbridge, were located behind the Shoulder of Mutton Inn at Mytholmroyd and provided a crossing over the Elphin Brook.

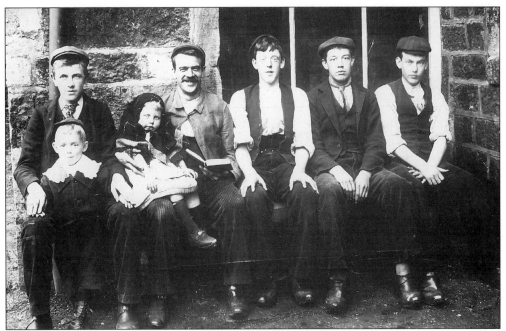

This group was photographed by Sunderland and Horsfall of Scarbottom, Mytholmroyd. Even the clogs on the little girl have been well polished for the occasion.

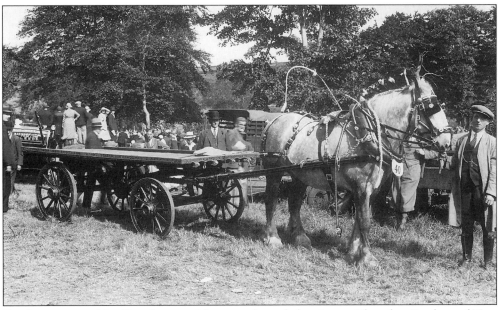

On show is entry No.40, a decorated horse and cart belonging to Thornber Brothers of New House Farm, Mytholmroyd.

Still operating as a general grocer, although now also as an off-licence, is Woodroyd Stores, Caldene House, situated on Burnley Road, Luddenden Foot. Since this photograph was taken Woodroyd Gardens have been built to the left of the store.

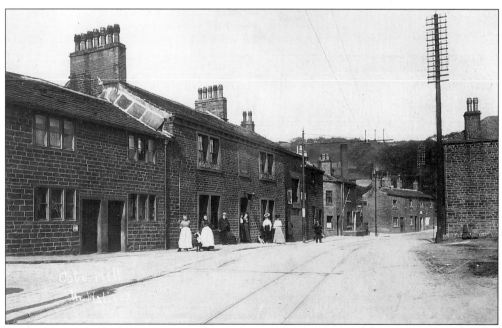

Looking up Cote Hill, Burnley Road, around 1905. The name of Thomas Frost appears above the door of the Peacock Inn. In *Robinson's Halifax Directory* of 1905 he is listed as the licensed publican. The Rose and Crown Inn, further along Cote Hill, is listed in the same directory as a beerhouse with Robert Hoyle as its publican.

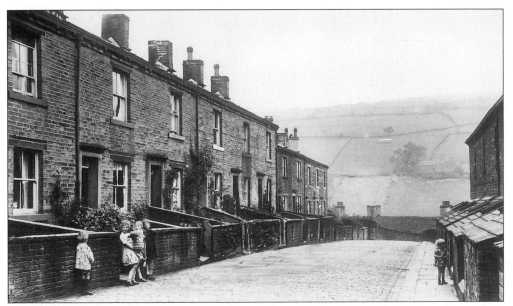

Apart from some minor alterations to doors, windows and walls, little has changed since this photograph was taken of Booth, Luddenden. As the road dips the chimney stacks of the Woodman Inn can be seen. The Woodman closed in December 1949, having been a public house for over 100 years.

The Hinchliffe Arms Hotel is signposted down Church Bank Lane in this photograph looking up Cragg Road, Cragg Vale. The Sportsman Inn, which occupied part of the Gates End buildings on the left, was closed in 1959.

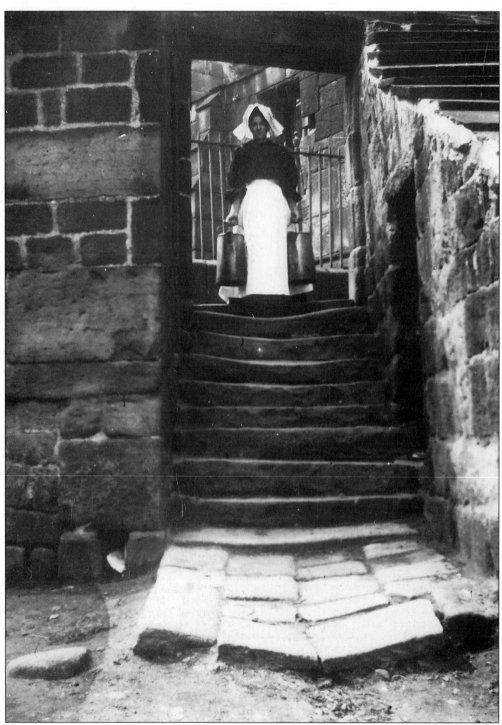

This photograph has contemporary reference, the area having gone through the worst drought in recorded history. This lady is seen, earlier this century, descending the steps by Heptonstall 'old' Church carrying two water cans. Perhaps she is on her way to the pump at the 'top o'th town'. The archway bears the date 1765.

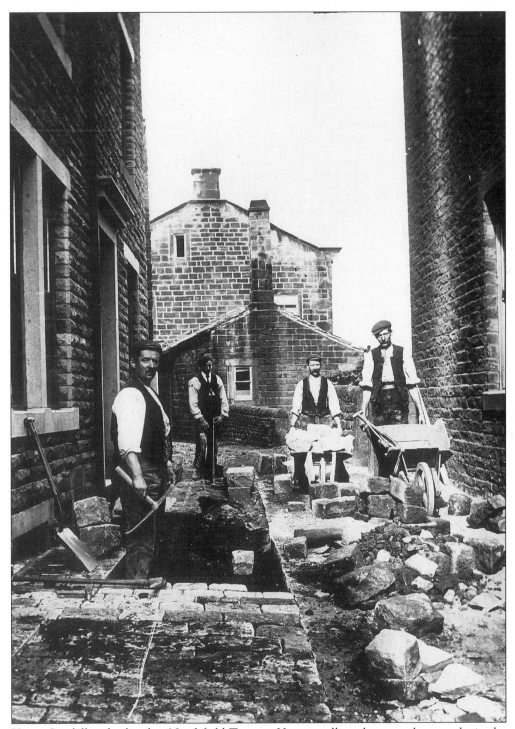

Henry Sutcliffe, who lived at Northfield Terrace, Heptonstall, took many photographs in the early part of this century. This could be one of them as it shows his house at Northfield Terrace but perhaps he is just one of the men taking a break for the camera.

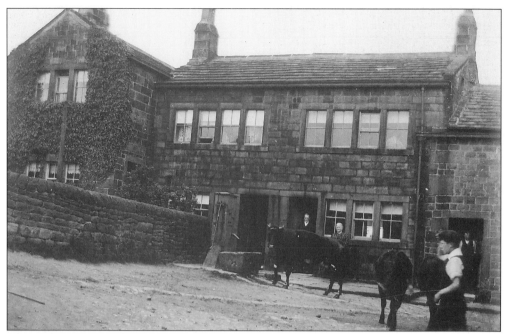

The current sign on these farm buildings at Heptonstall states Caycroft Nook. Old ordnance survey maps and directories of the period refer to it, however, as Keycroft Nook. There is an interesting pump in the middle of the photograph, although this and the trough have long gone.

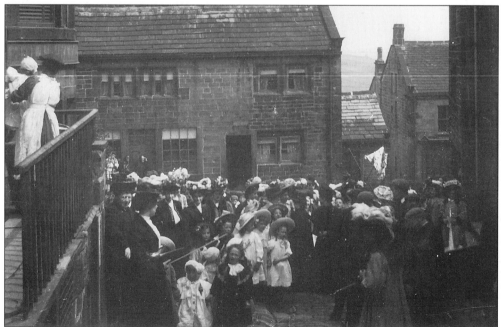

These children are assembled in Towngate, Heptonstall. At first glance one of the ladies on the left looks to be carrying a large cane which, on closer inspection, is more likely to be a bow as she also appears to be carrying a violin. The building, top left, with a round frontage housed the premises of Thomas Hollinrake, tailor and draper.

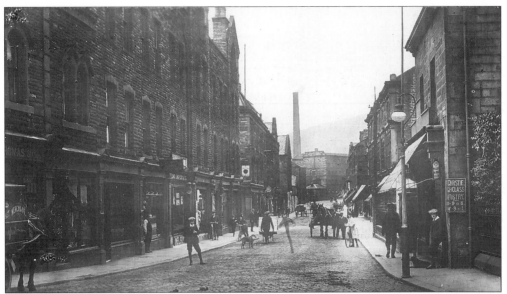

This picture of 1915 shows a busy scene looking along Market Street, Hebden Bridge. Market Street was developed in the early 1770s as part of the improvements to the turnpike road through the Calder Valley. A new and wider bridge was built in about 1772 as, until then, the main Calder Valley route still crossed the river over the narrow Old Bridge.

The Old Bridge at Hebden Bridge was built around 1510, replacing the wooden bridge first recorded as long ago as 1347. The many repairs to the packhorse bridge are inscribed on the bridge itself. The oldest inscription, seen in this photograph, states, 'Repaired by Help of Sessions 1602, John Greenwood'. John Greenwood was probably the Surveyor of the Highways. The fact that a grant was given by Justices of the Peace at their quarterly session, to repair the bridge, indicates its importance at that time.

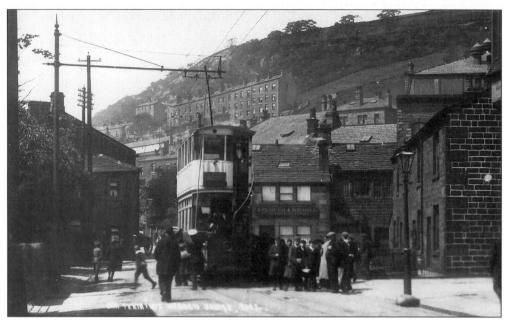

Queens Terrace can be seen on the hillside, above West End, in this view of Hebden Bridge. Tramcar No.82 stands at the Hebden Bridge terminus; the route to Hebden Bridge was the longest in the Halifax tramway system.

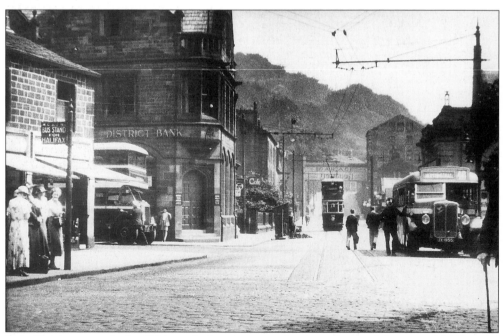

New Road was made in 1806 to further improve the turnpike road between Halifax and Todmorden. Here, looking along the road from West End, Hebden Bridge, the overhead gantry linking parts of Crossley's Mill can be seen above the in-bound tram.

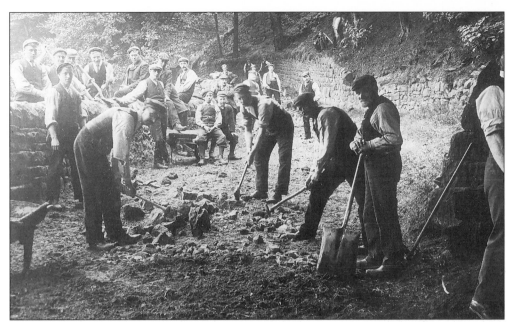

As a consequence of the local weavers' strike, some of the Hebden Bridge strikers set up the Eaves Self-Help Manufacturers' Society. The men bought two old silk mills at the Eaves Bottom Estate, renovated them, and installed second-hand looms. The venture ended however, in 1911, due to the depression in the trade at that time. Here the men are seen working at Eaves Bottom in 1907.

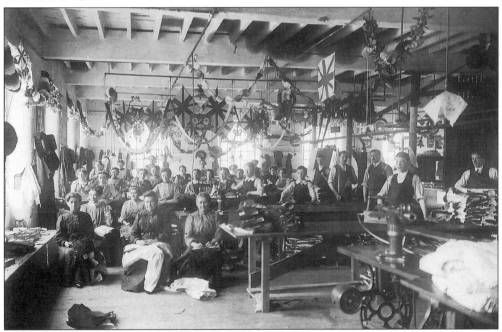

Fortunately for the Calder Valley, photographer Crossley Westerman, of Hebden Bridge, has recorded many of the changes and events that have taken place in the area. Just one of his many excellent photographs, this picture is taken inside one of the mills of the Calder Valley and shows the machine room decorated for the Coronation of King George V in 1911.

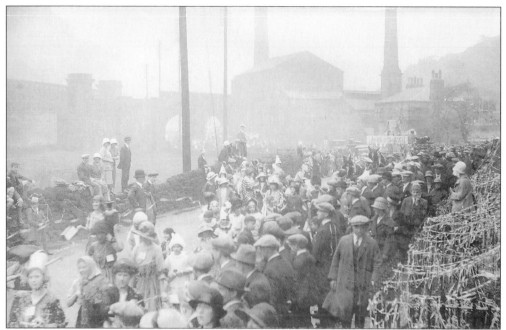

Viewed from Woodbine Place, this procession meanders its way through the Whiteley Arches past Calderside, on the main Halifax to Burnley Road. The arches were named after the nearby textile works of John Whiteley, now demolished, but here clearly seen next to the arches.

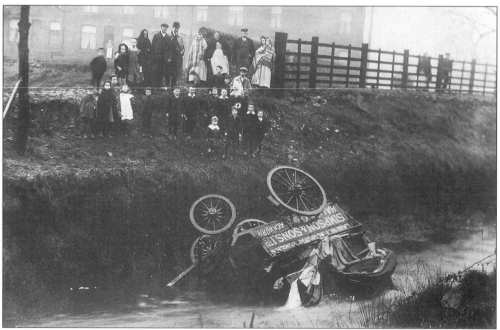

The property of Simpson & Sons Ltd, Halifax, this furniture cart came to an unfortunate end at Thistle Bottom, Hebden Bridge in 1906. John Simpson started his company in Woolshops in 1815. In 1884 the firm opened its extensive showrooms in Silver Street, which were spread over five floors and totalled over one and a quarter acres.

Six
Sowerby Bridge
and the Ryburn Valley

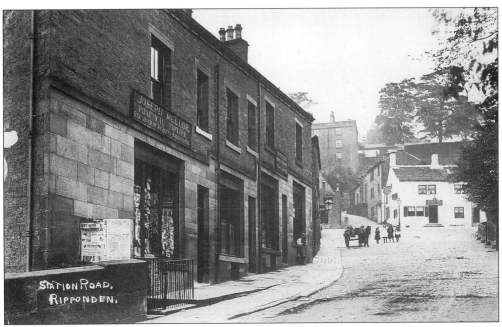

This postcard, entitled Station Road, Ripponden is actually looking up Elland Road towards the village centre. Stationer and newsagent Joseph Mellor, on the left, occupied the premises on Elland Road for many years. Further up, the girl diligently reading is leaning against the grocers shop of John Holden.

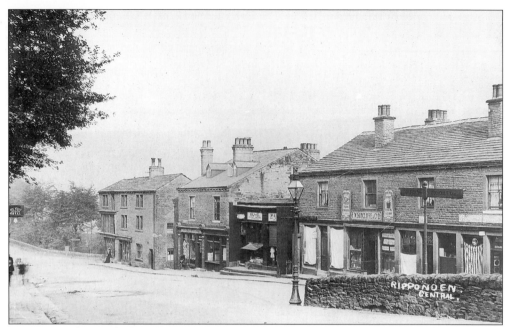

A pram stands outside the plumbers and ironmongers, C. Garside and Sons in this photograph of Ripponden. The Post Office is visible just behind the Halifax and Rochdale sign, next to the chemist, F.W. Sutcliffe, on Halifax Road.

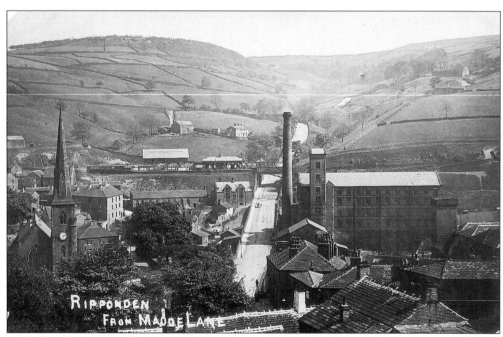

A Hughes Railmotor pulls into the Ripponden and Barkisland Railway Station in 1909. Motor trains were introduced to the Rishworth Branch on 1 March 1907. St Bartholomew's Church, on the left, was consecrated by the Bishop of Ripon on 22 October 1868, the fourth church to have been built on this site.

Seen here is one of the ancient highways of the district, part of the main Roman road linking York to West Chester. In John Ogilby's *Britannia* of 1675, the road is shown to pass Barkisland Cross (seen in the far distance), down what is now Ripponden Old Bank and over the 'stone bridg' in Ripponden. The road continued up Ripponden Old Lane towards Blackstone Edge. Later it became the main packhorse route and remained as the principal road through the village until the construction of the turnpike in the 1770s.

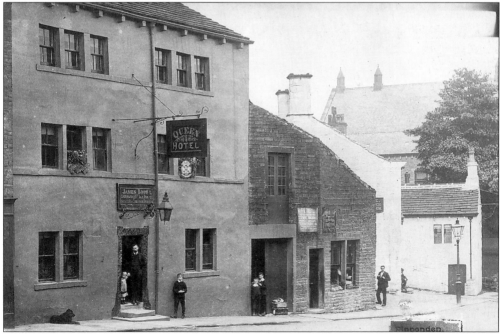

The Queen Hotel in Ripponden was built around 1800. Originally The Stansfeld Arms, The Queen has had many names including The Prince of Orange, The Holroyd Arms and The Queens Arms. James Booth was the landlord when this photograph was taken around 1905.

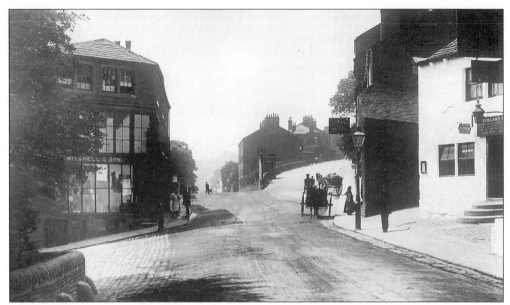

The premises of George Mitchell, auctioneer and valuer, known locally, for obvious reasons as the Crystal Palace, are on the left in this photograph of Ripponden. In 1873, with the lifting of the toll on the Elland Turnpike Road, George Mitchell bought the Toll Bar House and rebuilt it on top of his premises.

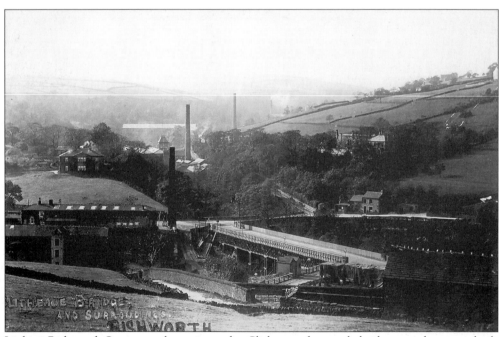

Linking Rishworth Station to the main road at Slitheroe, the trestle bridge, seen here, was built in 1880. The timber bridge was strengthened in 1923 but in 1952 it was not deemed financially viable to make further repairs and, with its demise, the station was closed. The trestle bridge was itself demolished the following year in 1953.

A familiar sight for many years was the Halifax Building Society advertisement on the railway bridge at the end of Station Road, Sowerby Bridge. The sign for the New Inn on the right, advertises BYB, Bentley's Yorkshire Beers.

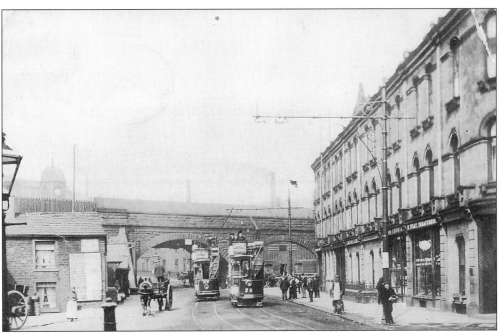

Taken a few years earlier than the previous photograph, but at the same location, these two tramcars pass on the loop in front of the Ryburn Buildings which were erected in 1884.

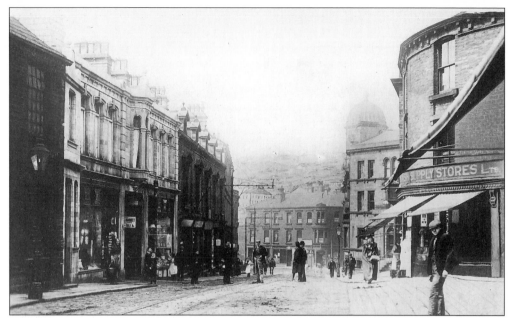

Seen from along Town Hall Street towards County Bridge, the Penny Bazaar occupies the rather ornate building on the left. The building has been used for many purposes; the Jubilee Cafe was located here and the first floor was once a billiard hall. The Sowerby Bridge Tourist Information Centre has recently vacated the premises which are now being renovated.

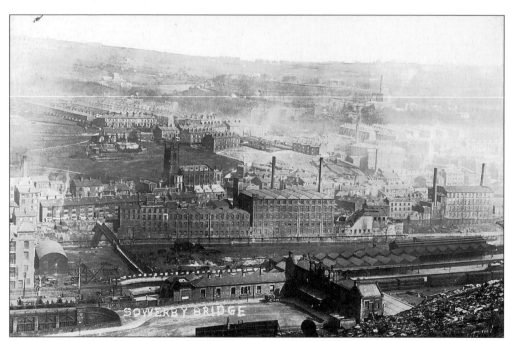

A predominantly industrial Sowerby Bridge with mills lining the River Calder seen here in about 1906. Back Wharf Street is linked to the railway station by a footbridge across the river. Christ Church, built in 1820, can be seen on the far side of Wharf Street, in the middle of the photograph.

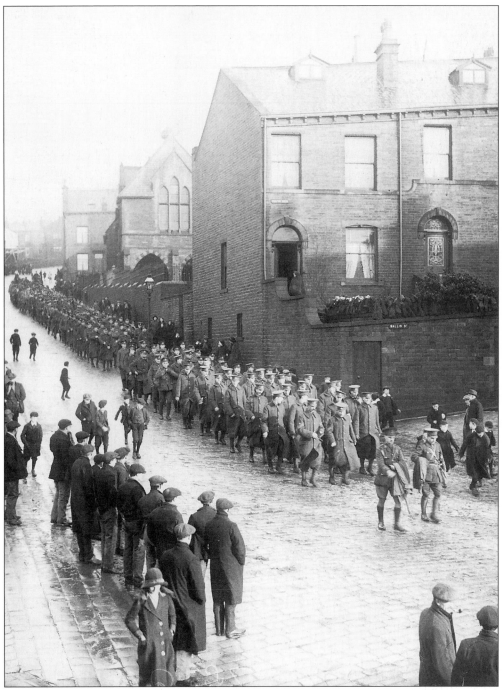

These troops are heading down Tuel Lane, past the end of Wallis Street this photograph taken around 1915.

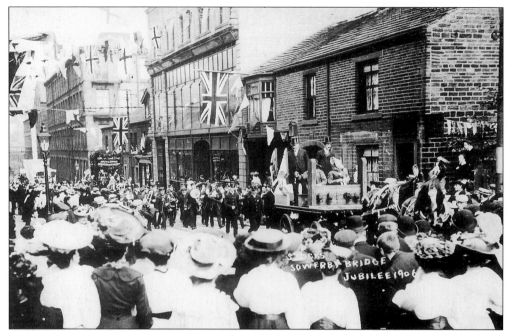

Celebrating fifty years of the Sowerby Bridge Urban District Council, this procession is proceeding up West Street, Sowerby Bridge. Two rogues sit secured in the stocks on the first cart which is passing the entrance to George Marshall's, practical chimney sweep.

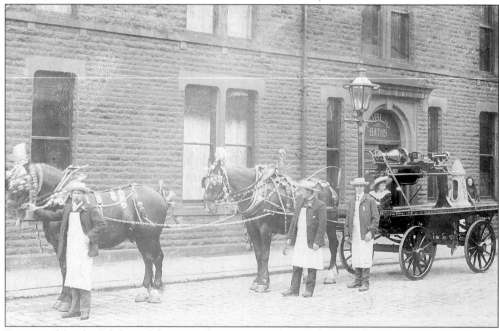

Decorated for the Jubilee celebration, this team stands outside Sowerby Bridge Public Baths on Hollins Mill Lane. The cart carries a lathe as part of the display for W. Newsome and Son Ltd, machinery merchants and brassfounders, also of Hollins Mill Lane. The team won the first prize of thirty shillings for the best groomed and cleanest gears.

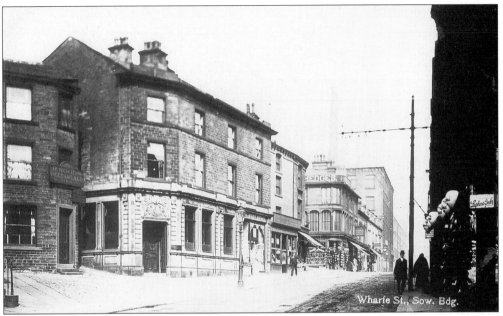

The 'globes' of Stead and Simpson Ltd, can be seen on the right in this picture of Town Hall Street, Sowerby Bridge. One of their competitors, Hedges and Company, bootmakers and dealers, displays a large sign at the bottom of what was then Tuel Lane.

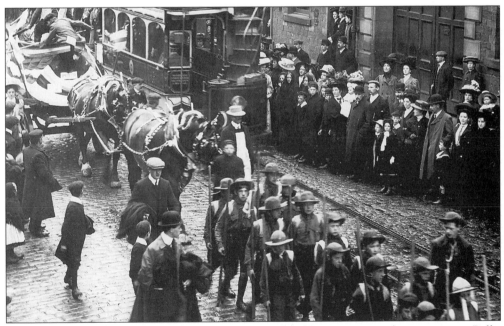

Another Sowerby Bridge procession, this time on Wharf Street, passing the entrance to Pollit and Wigzell, once the largest engineering firm in the town. The company was founded in 1786 by Timothy Bates and became famous for its steam engines which were exported throughout the world. In this picture a tramcar forces its way past the procession, heading towards Triangle, while what would appear to be a lifeboat enters the picture top left.

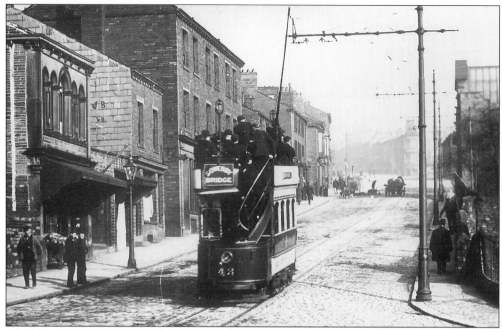

Tramcar No.43 starts its climb up the steep slope of Bolton Brow, Sowerby Bridge. Note the horse and cart in the distance using the tram track to ease their journey.

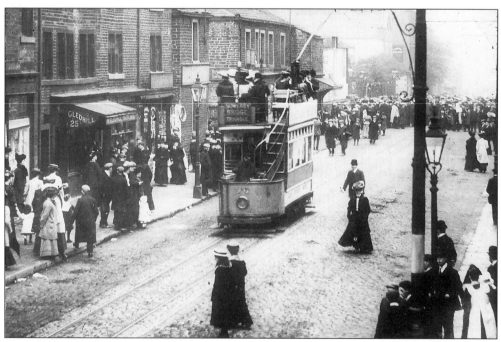

On its way to Triangle, tramcar No.70 is passing the butchers shop of William Gledhill, a business that operated in Sowerby Bridge for over 150 years until its closure in 1984. The Commercial Inn is 'three doors on'. The properties immediately beyond the inn have since been demolished, this now being the bottom of the new Tuel Lane. Note the large crowds gathered outside Christ church.

The fountain on the right, in this photograph looking towards Towngate, Sowerby, was erected in 1900 in memory of John Rawson of Brockwell. John Rawson owned considerable property in Sowerby including The Star Inn and adjoining buildings, Castle Hill Farm, Town End Farm, White Windows and Bentley Royd. In 1862 he rebuilt the almshouses at Sowerby at a personal cost of over £1,000; these stood opposite the seventeenth-century Sowerby Hall which can be seen behind the fountain.

The Congregational Church, Sowerby, is in the centre of this photograph. The church, which was demolished in June 1980, was designed by John Hogg and opened in 1861. The horse and cart in front of the church is approaching the bottom of Rooley Lane.

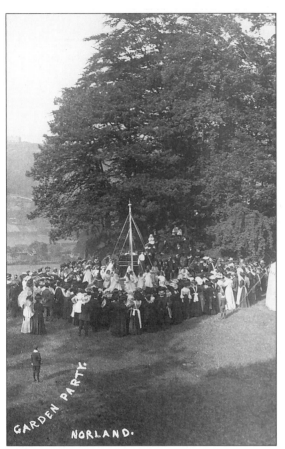

Enjoying a pleasant day out, these people are gathered around the maypole dancers during a garden party at Norland. A piano can be seen under the trees behind the maypole.

These children are seated on Norland's famous Ladstone Rock. In John Watson's *History of Halifax*, 1775 he described the rock under the chapter 'Druidical Remains in the Parish of Halifax', as 'a very ponderous stone, which projects over the side of the hill and has a very uncommon appearance'. He goes on to conjecture that the name could signify that the place was used by the Druids to administer justice.

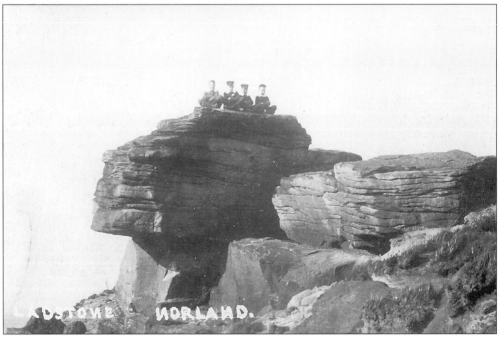

Seven

Sport, Leisure
and People

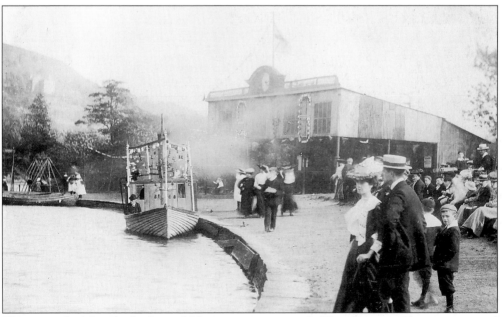

Waiting at the lakeside the Sunny Vale steamer awaits trade. The pleasure gardens were opened in 1883 by Joseph Bunce, whose family ran the gardens until they sold them in 1945. Following failing attendances the gardens closed four years later in 1949.

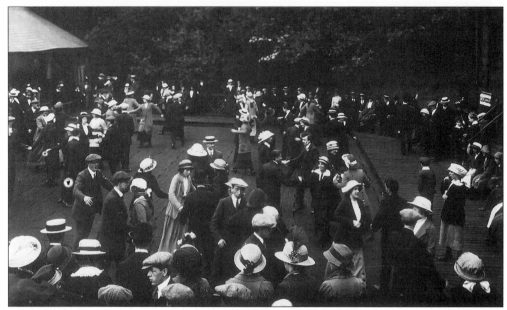

The pleasure gardens at Sunny Vale, Hipperholme attracted 100,000 people a year in their heyday. Here an open air dance is seen in full swing.

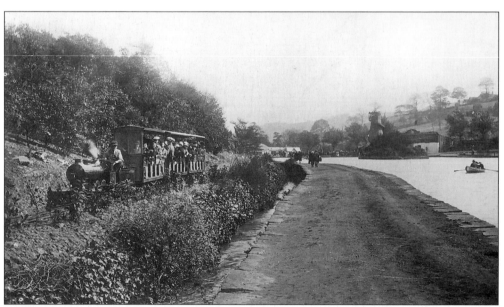

Travelling by the lakeside at Sunny Vale is *Baby Bunce*, the miniature railway engine. The engine started life under the name *Little Giant* and ran initially on Blackpool's south shore. The engine moved to Halifax Zoo in 1910 and remained there until the zoo's closure when it was put into storage before coming back into service at Sunny Vale pleasure gardens.

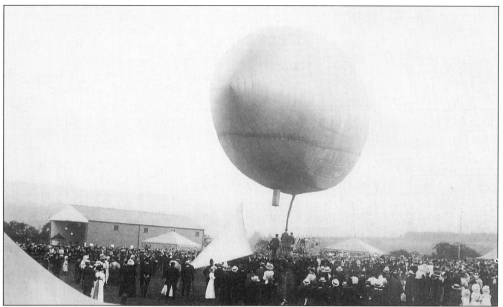

The arrival of Captain Herbert Spencer at Halifax Zoo on 3 July 1909 created tremendous interest amongst the people of the town. Captain Spencer was to provide Halifax with an early introduction to flight with his balloons and airships. He returned on numerous occasions to further demonstrate his flying prowess. Here he is seen about to take off in one of his airships.

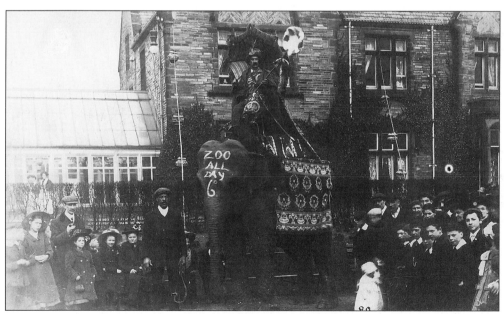

Keeper John Aaron stands next to the Indian elephant outside the mansion at Halifax Zoo. Adjoining the mansion were the splendid tea rooms; the waitresses can be seen peering over the hedge on the left.

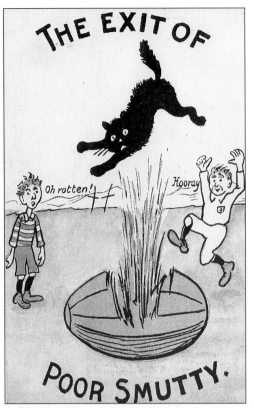

The Exit of Poor Smutty, presumably drawn by one of the opposition in the 'Black Cat Year' of 1906/7. Smut turned up at the Thrum Hall pavilion on 17 November and the team immediately started a run of success: seventeen games without defeat, sixteen having been won. Smut became quite famous and was even presented with a silver collar from the Black Cat Cigarette Company.

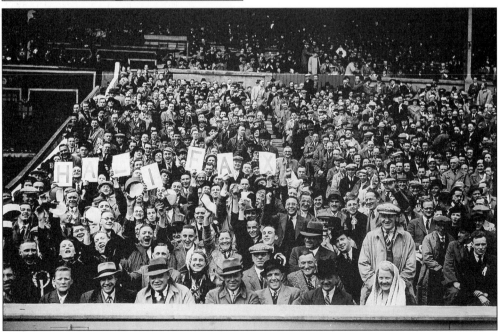

No, not quite Thrum Hall, but a section of the crowd that watched their 'heroes' beat Salford, at Wembley. Had the match started? Were Halifax winning? Had they already won, or was it just confidence that caused so many cheerful faces?

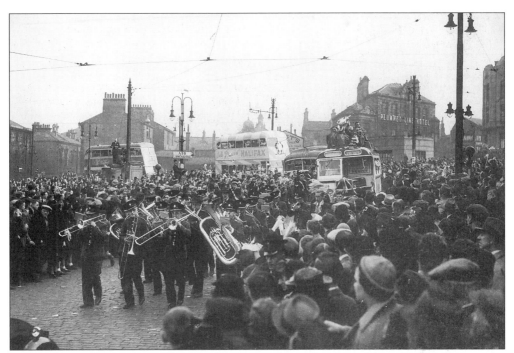

Led by the Lee Mount Brass Band and with the streets lined by thousands, the 'conquering heroes' pass through Bull Green on their way to the Town Hall. The 'heroes' were the victorious Thrum Hall side that had beaten Salford at Wembley, 20-3, in the 1939 Cup Final.

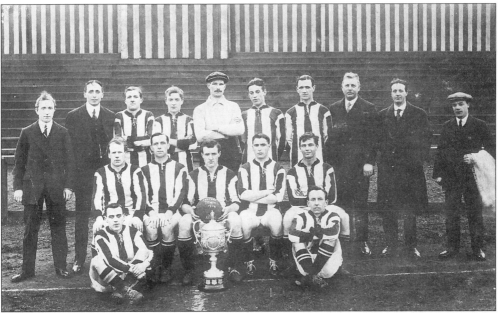

The 1913-14 season brought the first ever trophy to Halifax Town AFC when they won the Bradford Charity Cup. Goalkeeper Bob Suter was signed that year from Goole Town. On 20 April 1929, when injury had left the team without a goalkeeper, Bob turned out for his last game and set a record which still stands today: aged 48 years and 9 months, he became the oldest Englishman to play in a football league match.

An excellent advertisement for The Shears; these gentlemen are standing outside the inn at West Vale. The building directly behind the group is West Vale House which is situated on the corner of Stainland Road and Saddleworth Road.

This group of locals was photographed outside the Devonshire Arms which was situated on Garden Street North, New Bank. The pub closed in 1937.

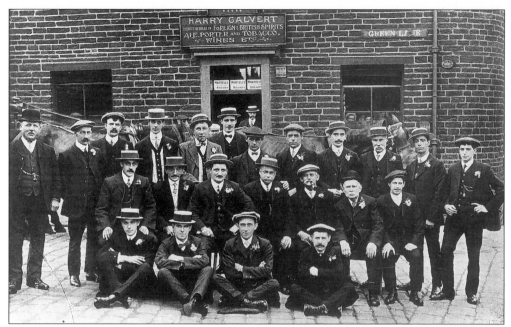

The horses in the background would suggest that these gentlemen, pictured outside the Stannary Inn, were about to depart on a 'pub trip'. The Stannary Inn was situated on the corner of Green Lane and Stannary Lane and was Richard Whitaker's first pub and alehouse. Opened in 1859, the pub closed over a century later in 1967.

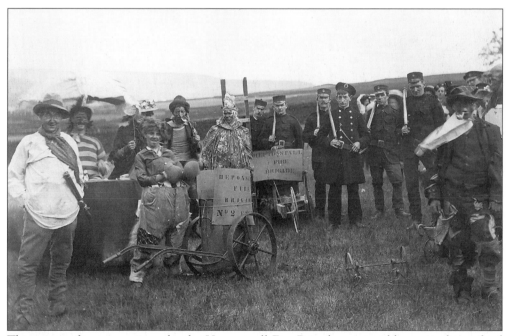

This group of men pertain to be the Heptonstall Fire Brigade, presumably engaged in a fund raising event. How fortunate to have such a fine bunch of fire fighters to call on in an emergency!

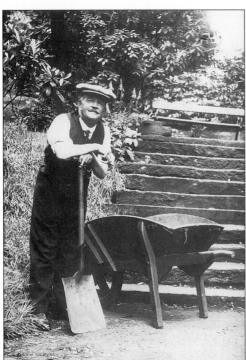

Postmarked 1934, the year that Shibden Hall was opened to the public, this postcard features Tommy Tupper who was the head gardener there.

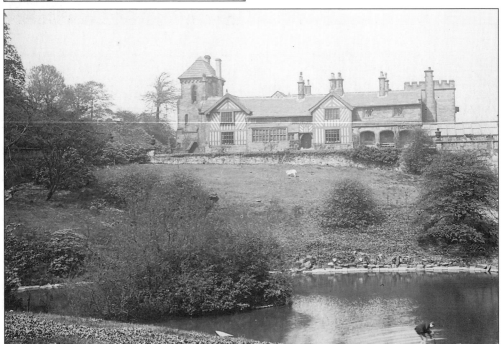

Shibden Hall was built around 1420 by William Otes. The hall came into the possession of the Lister family in 1619 and remained in the family for over 300 years. A.S. McCrea purchased the estate in 1923 and offered it to the Halifax Corporation as a public park. The renowned historian John Lister continued to live in the hall until his death in 1933. The following year it was opened to the public as a period museum.

This well dressed group are standing outside the entrance to Bankfield, the family home of Edward Akroyd. When Akroyd first purchased the house in 1838 it was relatively small. Alterations and extensions made in 1856, and particularly those made in 1867 at a cost of £80,000, turned the house into one of considerable size containing one hundred rooms, including twenty six bedrooms. Halifax Corporation bought the property in 1887 and opened it to the public as an art gallery, museum and park. This photograph is taken around this period.

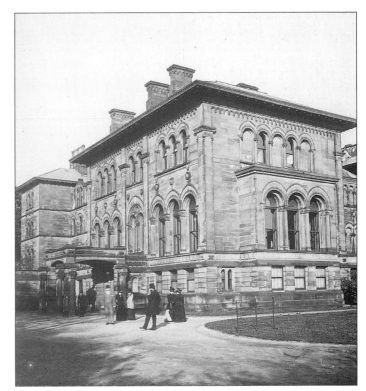

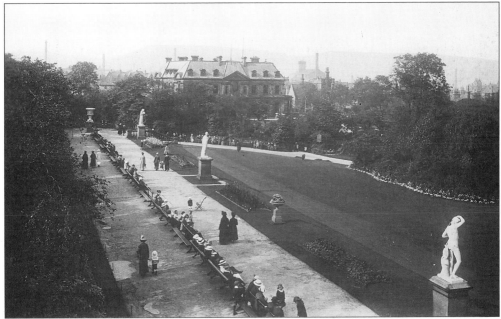

A sunny day in People's Park. This view shows the splendid grounds and statues being enjoyed by numerous people enjoying a pleasant day out. The 'keep off the grass' ruling obviously worked in those days. The park, which opened in 1857, was planned by Sir Joseph Paxton on behalf of Sir Francis Crossley who presented this and many other fine gifts to the people of the town.

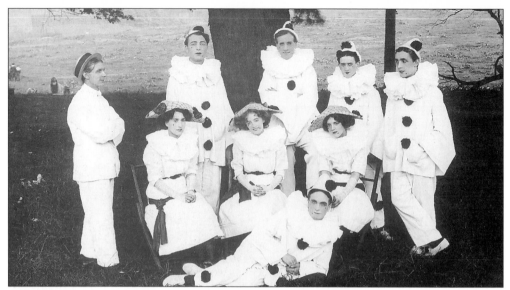

Harry Thorpe's Peerless Pierrots, shown in the Shay Gardens, Halifax. Harry is standing in the middle of the back row; seated in front of him is comedienne Zoe Coe who, together with Harry, formed an early comedy duo.

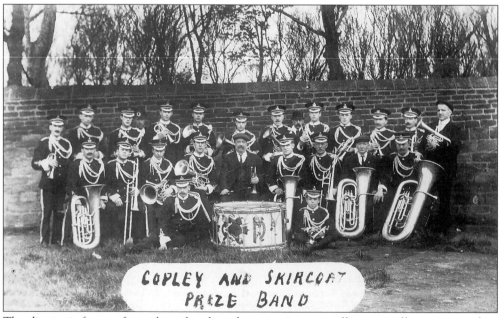

The district is famous for its brass bands and at one time virtually every village supported its own band. Perhaps not quite as famous as some of its neighbours, here we see the Copley and Skircoat Prize Band in their full regalia.

Regimental mascot Percy Wilson, photographed to help raise funds for the Halifax Courier's appeal during the Boer War. Born in 1893, Percy's father was TomWilson, the landlord of the Stump Cross Inn. Perhaps in joining the army in 1915, Percy achieved his childhood ambition.

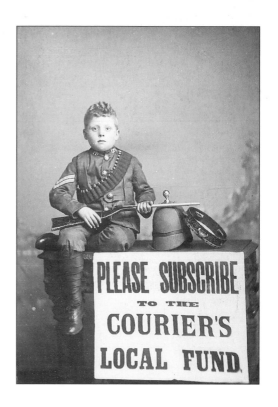

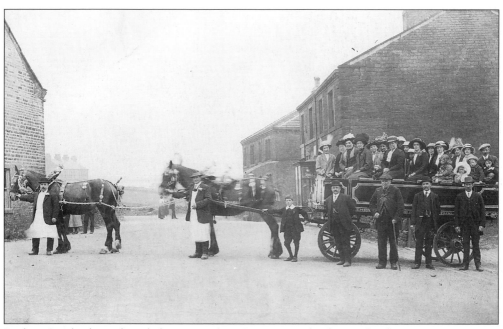

In their Sunday best, these ladies at Bowling Green, Stainland, pose for the camera prior to an outing. The building in the background at the top of Coldwell Hill was, for many years until its recent closure, a chemists shop.

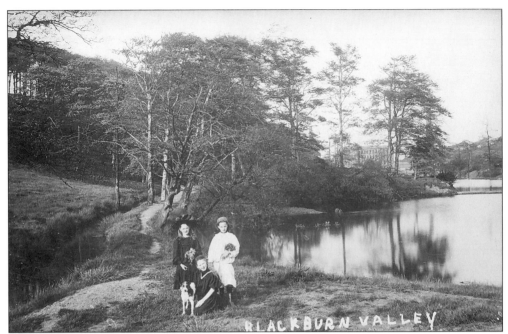

A tranquil scene in Blackburn Valley, Greetland, where these three young ladies have been picking flowers.

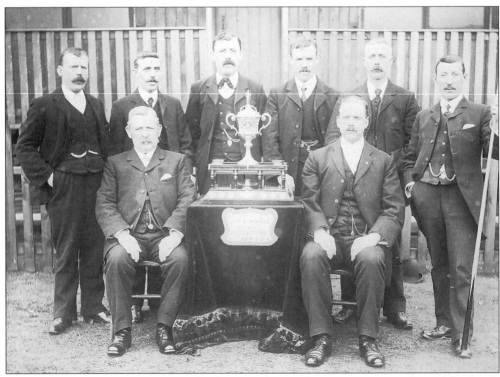

A display of the cup and medals won by the Ovenden Mechanics Institute in the Halifax Parish Billiards League in 1906-7. Not a particularly happy bunch, perhaps they expected to win more.

Eight

Transport

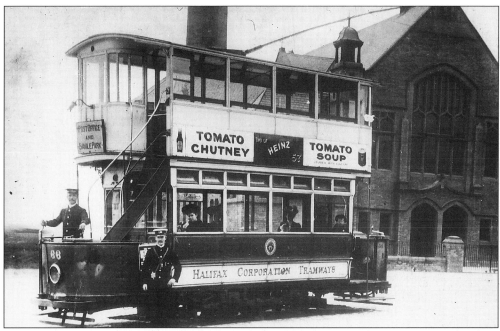

The driver and conductor of tramcar No.66 pose for the camera in this photograph taken at the top of Savile Park. The date is around 1906, the same year that No.66 received its top cover. Trams commenced running on the Savile Park route on 6 June 1899 and ceased on 28 July 1931. To help identify the location the building in the background is King Cross Wesleyan Sunday School, now demolished. However, the other structure, seen above the tramcar, is Wainhouse Tower.

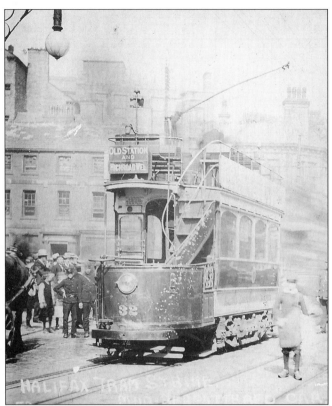

Photographed during the Halifax Tram Strike of 1906, this tramcar, splattered with mud, is situated on Commercial Street at the bottom of George Square. The strike action was taken following the dismissal of Theodore Chadwick who had been the driver of tramcar No.94 when it overturned on North Bridge, resulting in the death of two passengers.

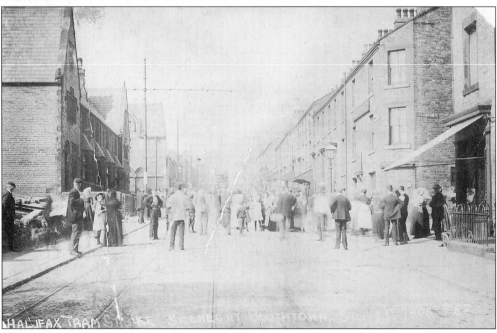

Although an inquest had cleared driver Chadwick from all blame, the Corporation refused to reinstate him. This photograph shows further disturbances during the strike, this time in a scene looking up Boothtown.

96

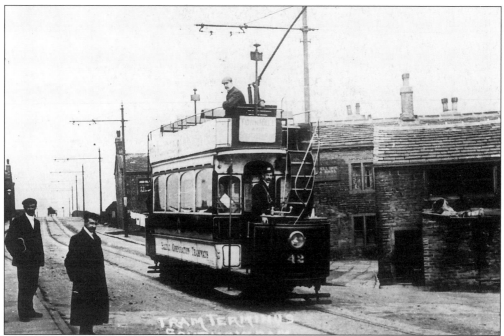

Tramcar No.42 waits outside the Blue Bell Inn at Bank Top, Southowram, before returning to the Town Hall. The route operated for thirty years, starting in 1901 and ending in 1931. The landlady of the Blue Bell Inn, when this photograph was taken, was Mrs M. Binns; the pub closed in 1906.

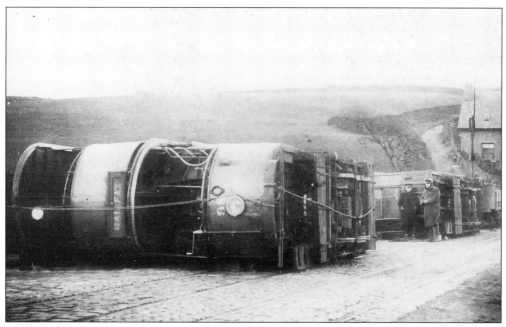

The wildest, most hazardous part of the Halifax Corporation tramway system was Catherine Slack, Queensbury. For many years the corporation had a wind gauge at nearby Crow Point to record the velocity of the wind. Measuring the wind did not particularly help these two trams which were blown over on 3 December 1920, causing injuries to several people.

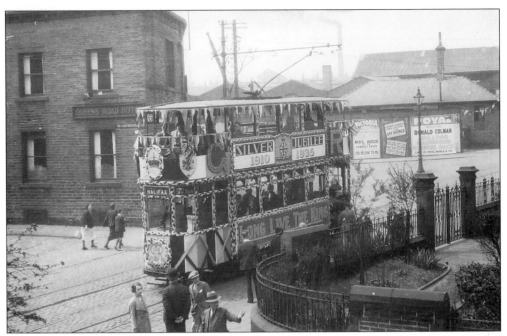

Decorated to celebrate the Jubilee of King George V and Queen Mary, this tramcar is passing Wadsworth Street on its way down Pellon Lane.

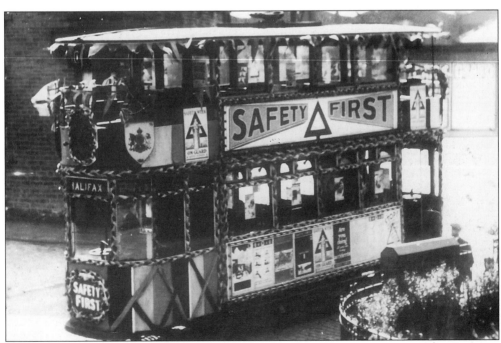

Same location and, presumably, the same tramcar, but the Jubilee signs have been removed and replaced with Safety First signs. Virtually all the other decorations are the same.

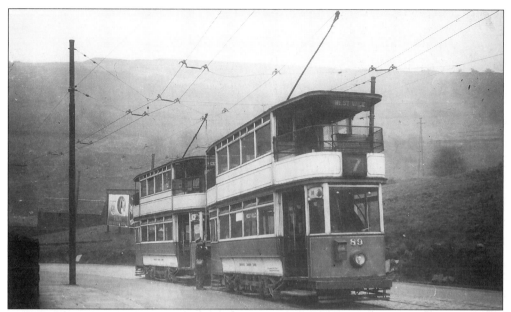

The Huddersfield to West Vale trolleybus service commenced on 28 May 1939, the tramway service having ceased to operate the previous day. The problems caused by the introduction of additional overhead lines while the tram service was still running can be seen in this photograph taken above Ainley Bend at Elland, on 5 April 1939. The conductor can be seen attempting to free the tram pole of tramcar No.96 after it became entangled with the trolleybus wire. Eventually tramcar No.89 arrived and towed the troubled tram up the hill to free the pole.

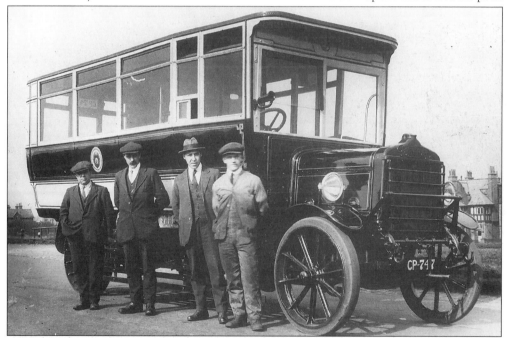

The Halifax motor bus service began on 14 October 1912 on a route from the Rook Hotel, Queens Road, to Mount Tabor. These officials are standing alongside bus No.5 at Savile Park. The bus, a Daimler, was purchased in July 1916 and remained in operation until 1927.

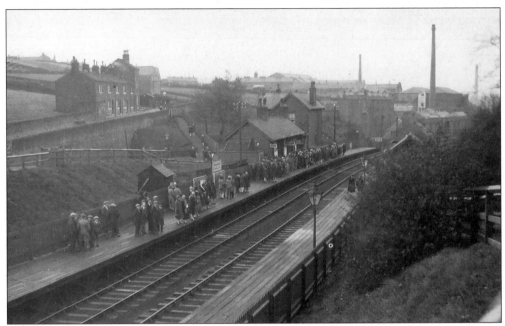

Passengers gather on Ovenden Station for a trip to Blackpool. The occasion was the twenty first birthday of Trevor Standeven, of Standeven and Company Ltd. This is one of a series of photographs and it would appear that most of the workforce of Ladyship Mills joined the celebration trip. Ovenden Station, situated between Ovenden Road and Old Lane, opened on 2 June 1881 and closed in May 1955.

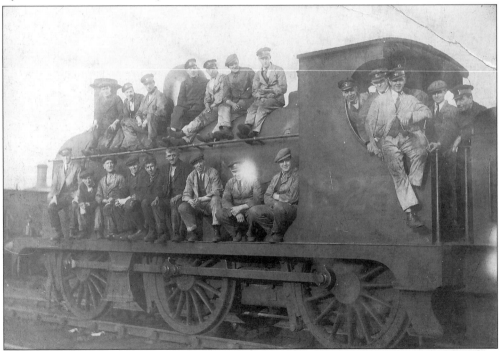

Mechanics and engineering staff pose on an Aspinall 0-6-0 engine at Sowerby Bridge. This type of engine could be seen on the Calder Valley line for over seventy years.

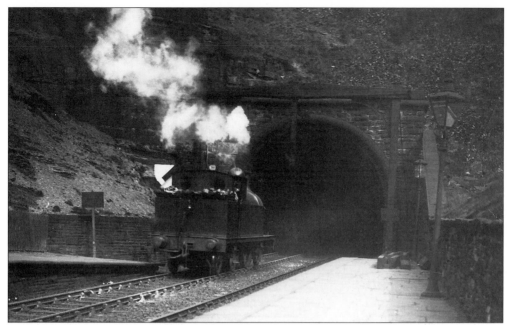

On the Lancashire and Yorkshire Railway, Halifax to Low Moor line, this engine is about to enter the 388 yard long Hipperholme Tunnel. The tunnel, which takes the line under Brighouse Road, is seen here in the direction of Lightcliffe.

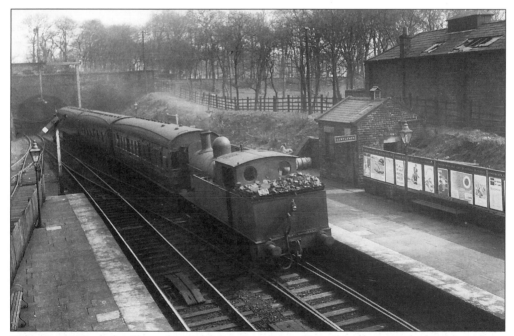

Taken in 1937, and still on the Halifax to Low Moor line, this photograph shows a train at Lightcliffe Station. The station opened on the same day as Hipperholme Station ie. 7 August 1850, and closed in June 1965.

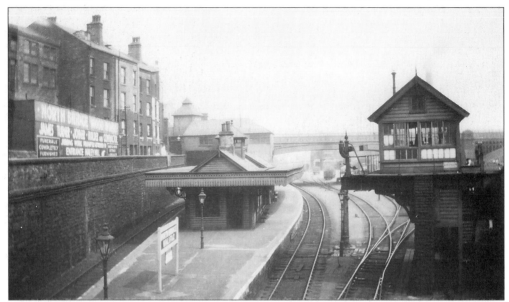

The completion of the new North Bridge in 1871 made possible the railway line to Ovenden. The new bridge was built eleven feet higher than the previous bridge, high enough to allow rail traffic to pass beneath. The line between Halifax and Ovenden opened on 17 August 1874. North Bridge Station opened in 1880 and closed in May 1955.

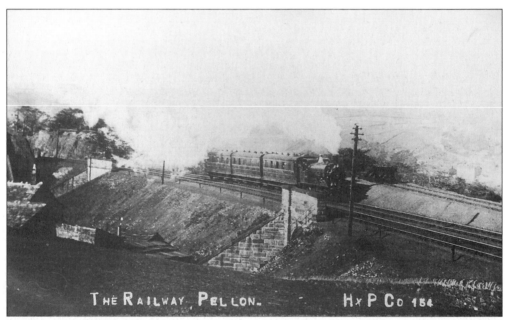

The line of the Halifax High Level Railway between Holmfield and Pellon was only three and a quarter miles in length, yet some 357,598 cubic yards of material was excavated and 226,047 yards of embankment constructed in addition to the stations. The cost of the line was approximately £300,000. The line was officially opened on 4 September 1890 by the Mayor, Alderman James Booth and closed to passengers in December 1916. This photograph shows a passenger train approaching Pellon.

Rush hour on Waterhouse Street? A slight congestion gave the photographer a chance to capture on film a combination of different vehicles. Trick photography perhaps, or were all the vehicles really that clean?

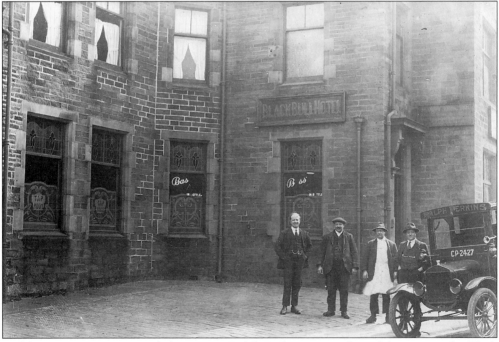

A delivery wagon, CP 2427, belonging to Ralph Perkins is seen here delivering to the Black Bull Hotel. Ralph Perkins was a mineral water manufacturer who operated in the early part of this century from Sod House Green, Ovenden.

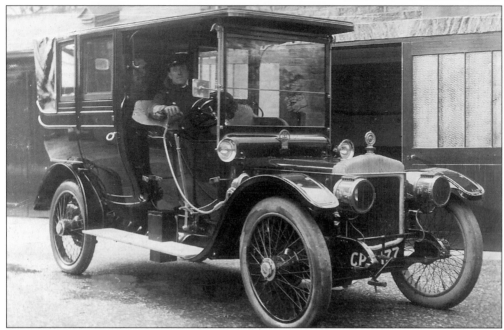

What would it fetch these days? This superb looking car was photographed, according to information on the back of the postcard, at Jubilee Road, Siddal.

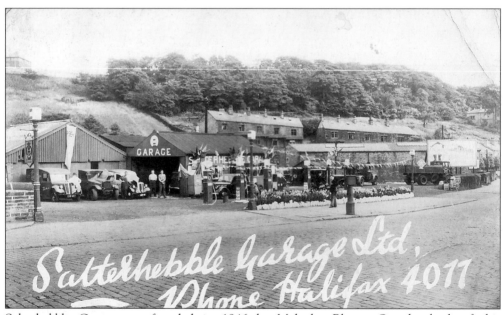

Salterhebble Garage was founded in 1946 by Malcolm Blazey. On the back of this advertisement card for the garage it states, 'the only service station in the area with a twenty four hour wide-awake service'. It also adds that, 'we do not indulge in white coats'. A 'dig' perhaps at its competitors' of dress at the time?

Two forms of transport are seen in this photograph. The first is obvious, with the large shire horse in the foreground. The second is seen above the horse and is Mytholmroyd Railway Station which was built on a viaduct and opened in May 1847.

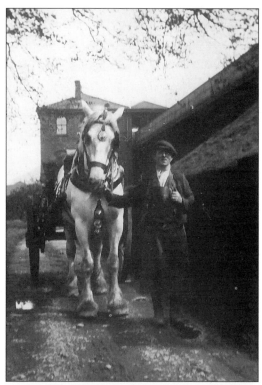

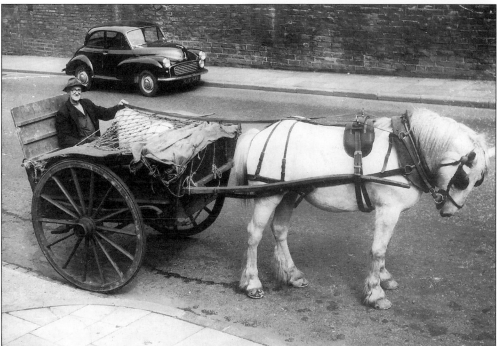

The information on the back of this photograph states, 'Mr Walter Greenwood of Far Royd Farm, Ovenden who drives his pigs to market by horse and cart, and who believes he is the last farmer to do so'.

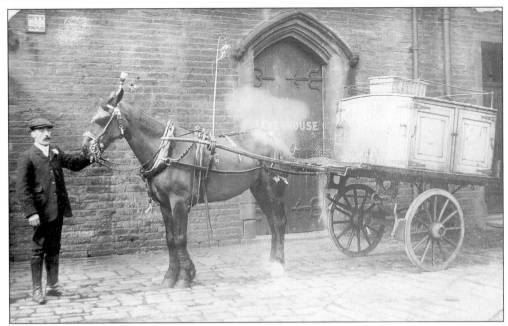

William Baker and Son, bakers and confectioners, operated from Bankfield Bakery, Boothtown. In this photograph of around 1906, William Baker holds his horse steady outside the bakehouse in Bankfield Yard. Notice the oven on the cart for keeping the bread warm.

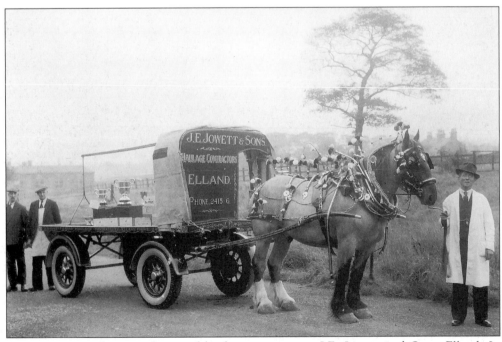

A prize winning horse and cart of haulage contractors, J.E. Jowett and Sons, Elland. In Robinson's Town Directory (1905) a J.W. Jowett operated a cab and carrier business from No.7 Briggate, Elland.

Nine
Schools and Churches

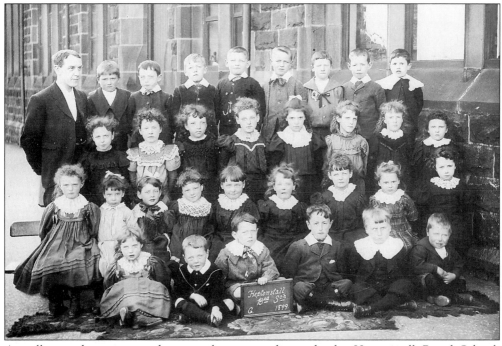

A well turned out group, these pupils are posed outside the Heptonstall Board School, Smithwell Lane in 1899.

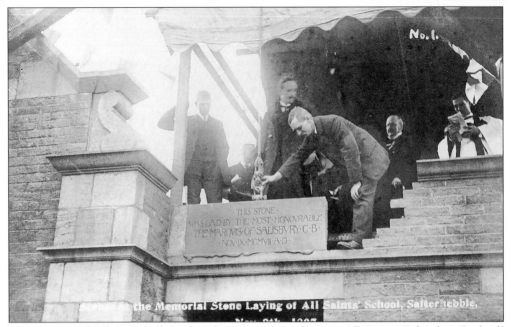

The Marquis of Salisbury laid the foundation stone for the new All Saints' School, at Dudwell Lane, Salterhebble on 9 November 1907.

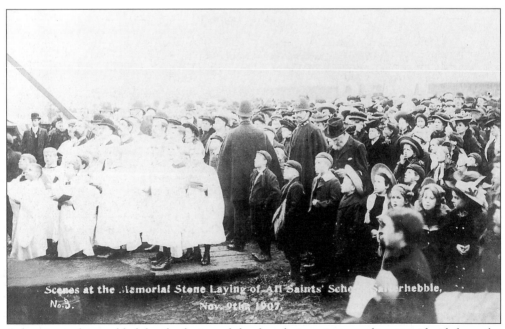

A large crowd assembled for the laying of the foundation stone at the new school; here the choir appear to have the best view. The school was opened, just under two years later, on 23 August 1909 by Admiral Sir Henry Rawson.

The laying of the foundation stone for the Girls' High School, Craven Edge, being performed by Mrs Howard Clay on 21 June 1930, in memory of the contribution made by Alderman Howard Clay to education in the district. The school was later renamed the Princess Mary High School following its official opening by HRH Princess Mary, Countess of Harewood on 21 September 1931.

The date of this picture of the Standard III class at the Bolton Brow Board School is unknown. However it is likely to be shortly after the school opened in 1897. The school was the second to be opened by the Sowerby Bridge School Board, the first being the Tuel Lane Board School, which opened in 1879.

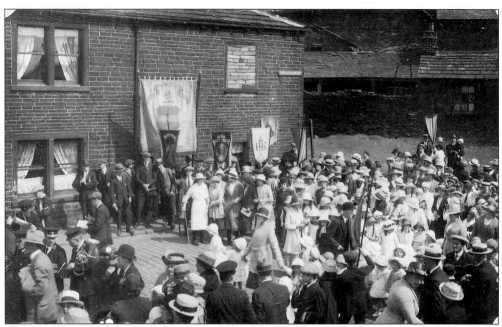

The Sunday School banner of St Mark's dominates this Whitsuntide parade on Siddal Lane.

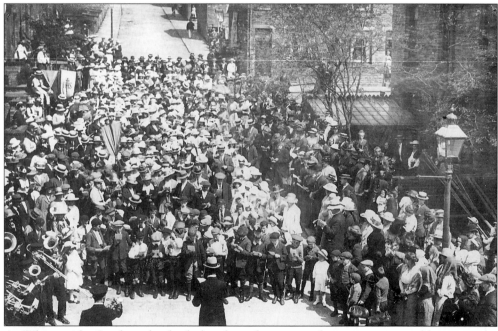

At Whitsuntide, Sunday school scholars from the various denominations would meet at the bottom of Ashgrove Avenue, Siddal, for combined singing of hymns before marching around the village.

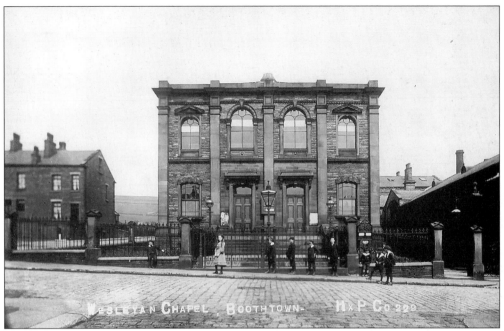

Now the Serbian Orthodox Church, this photograph shows the Akroydon Wesleyan Chapel, built in 1871, at Boothtown. The Sunday School building is to the right of the chapel.

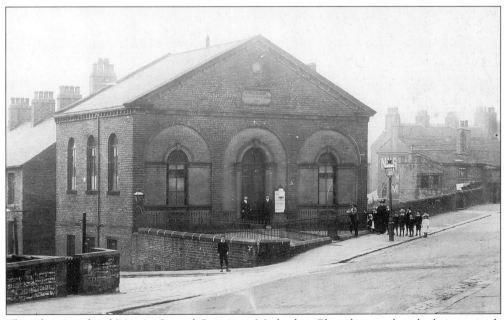

This photograph of Mount Carmel Primitive Methodist Chapel was taken looking towards Claremount Road, Boothtown. The premises under the chapel were initially kept as houses but were later converted to a school. Built in 1865, the building is currently used as a private day nursery.

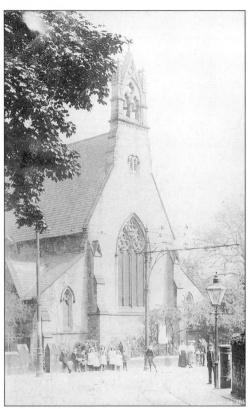

St James was built, in Bradford Road, as a chapel of ease to the Parish Church. The church, now demolished, was opened in 1871 and cost around £4,000 to build. One of the features of the church was its turret with two bells, clearly visible in this picture.

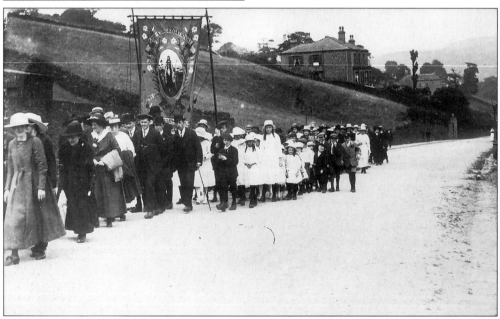

Holding their banner high, these Sunday school scholars from Zion Congregational are part of the Whitsuntide procession walking up Rochdale Road, Ripponden in 1906. The Zion Chapel at Ripponden opened in 1870 and was severely damaged by fire on 29 April 1902. The chapel was reopened on 4 September the same year.

This photograph would have been improved if the photographer had asked the ladies to stand in front of the railings instead of peering through them. However, it is still a pleasant picture that shows Lightcliffe Old Church which was built in 1775 to replace the original church that had stood on the site since 1529. In 1875 the new St Matthew's Church was consecrated and the old church became a cemetary chapel. Only the tower of the old church now remains, the rest, having fallen into disrepair, was demolished in the late 1960s.

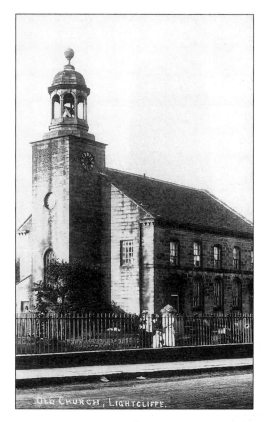

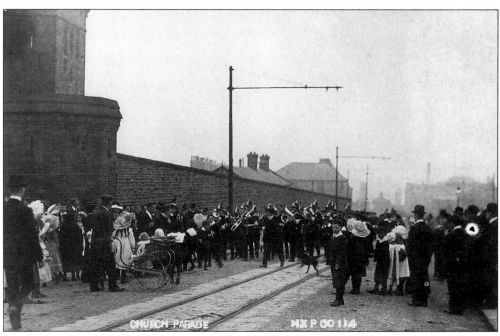

The band in this church parade, taken by the Halifax Photographic Company, is marching up Gibbet Street by the Wellesley Park barracks. Note the fantastic pram on the left.

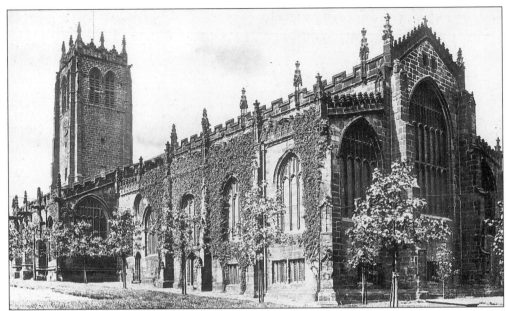

Built in the fifteenth century, the Halifax Parish Church is the third to occupy the site. Parts of the previous two churches, which dated back to around 1120, can be found within the present structure.

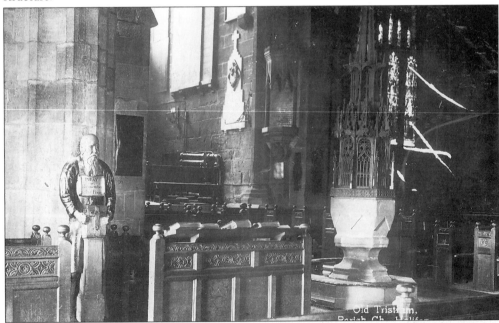

'Pray Remember the Poor' is the appeal on the plaque of Old Tristram who has stood in the Halifax Parish Church since at least the early 1700s. The statue is said to represent a man of that name who was educated in the workhouse and became a beggar when reaching manhood. His son followed his example, also becoming a mendicant, and both are recorded in the sixteenth century parish records. Although it is unclear when, it is known that the statue was carved by John Aked. The font cover, one of the finest in the country, was carved in the fifteenth century.

This troupe of well dressed musicians and entertainers of the Square Chapel concert party, were captured on film by Halifax photographer Arthur Vincent Wild.

This photograph was found amongst a collection depicting members of the Elland Primitive Methodists. This particular picture however, is actually taken outside the Salterhebble United Methodist Church.

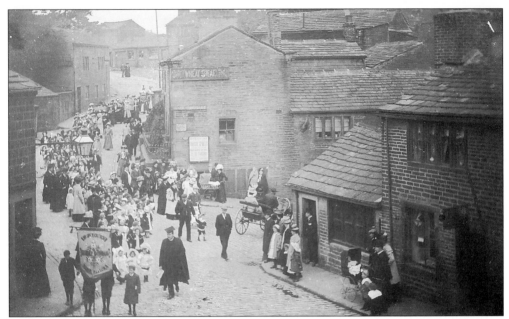

Walking down Church Lane, this parade have not long left Christ Church, Mount Pellon. A carriage is about to descend Brackenbed Lane past the Wheatsheaf.

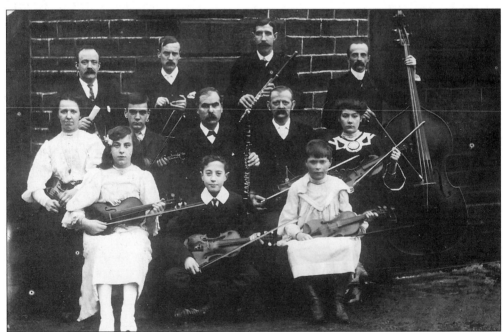

This band of 'merry' musicians have been photographed outside the Heptonstall Octagon. The Heptonstall Methodist Chapel is the oldest Methodist chapel in the world still in continuous use. The Society was founded by William Darney, a Scot 'of prodigious size', in 1742. John Wesley visited Heptonstall on twenty different occasions, first preaching there on 5 May 1747. In 1764 the Heptonstall Octagon was erected and on 6 July that year Wesley, on his tenth visit, preached 'in the shell of the new house'.

Ten

Events

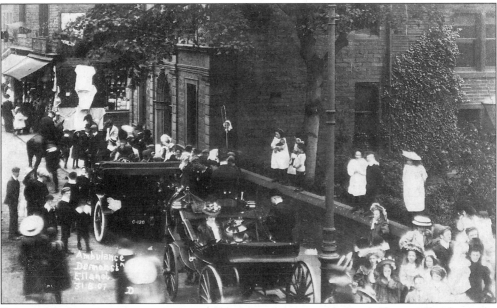

Presumably these carriages are awaiting official dignitaries outside South House, Elland, prior to the St John's Ambulance demonstration of 1907. The first of its kind in the town, the 'demonstration' proved to be a great success. Owing to the lateness of the Accrington Pipers the procession set off late but eventually, led by the Elland Band, arrived at the recreation ground. Attractions commenced at the ground with an Indian drill and pyramids. Competitions followed for the local St John's Ambulance brigades including drills and practical tests in first aid. The brigade from Todmorden were successful, and were awarded the Dempster Shield. A fire brigade competition was also held with eighteen entries. Harrogate won, with the brigade from J. Blakeborough and Sons coming second. However, following an appeal, Harrogate were disqualified and the first prize was awarded to the J. Blakeborough team.

In Affectionate Remembrance

OF THE

FIVE VICTIMS OF THE EXPLOSION & FIRE

WHICH TOOK PLACE AT THE

Wellington Mills, Halifax, Dec. 4th, 1873.

Mary Lee, Aged 18, Fitzwilliam Street. | **Elizabeth Jowett,** Aged 14, Bell St., Claremount.
Elizabeth Stott, Aged 13, Claremount. | **Margaret Ellen Morton,** Aged 11, John Street.

Annie Dawson, Aged 8, Queen's Road.

WHO WERE INTERRED IN ONE GRAVE AT STONEY ROYD CEMETERY, HALIFAX, DEC. 11TH, 1873.

Soon after daylight broke
Upon that fatal morn,
A loud report awoke
Alarm which none could scorn ;
A dreadful cry of " Fire !"
Was rais'd both far and near,
As flames ascended higher,
They filled all breasts with fear.

The hapless people there
Sought how they might escape,
For death approached them near
And for them seemed to gape ;
Now they rush'd from that scene,
With terror-stricken gaze,
The lurid fire shed its sheen
From the dread frightful blaze.

But some were left behind,
Alas ! that youthful " five !"
They no escape could find,
And all were burnt alive!
Deep sorrow strikes the heart
Of parent, lover, friend ;
So sudden call'd to part,—
This mortal life to rend.

Our nature—oh how weak,
When death comes face to face,
In vain we strive and seek
On earth a hiding-place ;
All must obey his nod,
Fulfil his dire decree :—
"Prepare to meet thy God !"
Nor from His warnings flee.

T. T.

A memorial card in remembrance of the five girls who died in the Wellington Mills explosion and fire. Work had commenced on a defective meter on 4 December 1873 and the main pipe had been plugged. Unfortunately the pressure of the gas forced the plug out and soon gas filled the lower floor until contact was made with a naked lamp. The inevitable explosion immediately set the mill ablaze and alarm spread thoughout the six storeys of Lister's Silk Mill. Despite difficulty with smoke and flames, many of the 120 workers on the premises escaped using a third floor gangway to another mill. Many others, however, suffered burns and injuries after jumping from windows. The mill was, apart from a section of a gable end, totally destroyed.

Taken by Thomas Heap, this photograph shows a large celebration bonfire, possibly for the 1902 coronation. Many of the dignitaries in the crowd are wearing medals, similar to those handed out on such occasions. Thomas Heap operated from Pinfold, Sowerby.

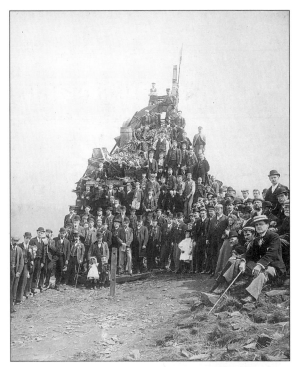

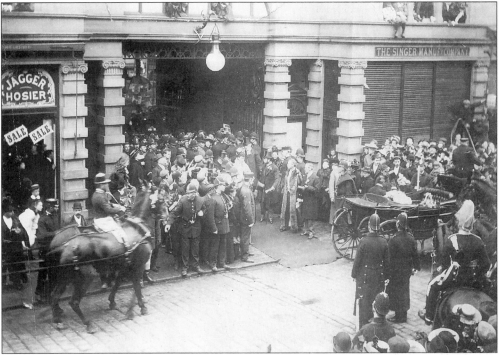

Crowds have gathered to greet the Duke and Duchess of York, later King George V and Queen Mary, on 25 July 1896 as they leave the Halifax Borough Market having just performed the opening ceremony. The Mayor, Alderman George H. Smith can be seen on the right in full mayoral regalia.

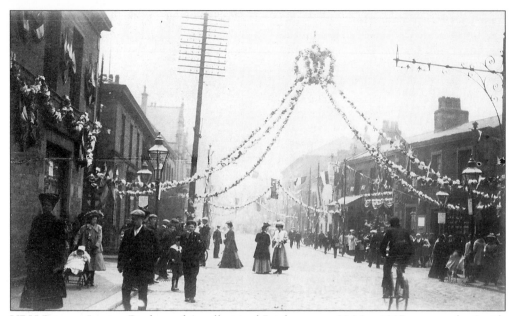

HRH Princess Louise, Duchess of Argyll visited Brighouse on 22 May 1907 to open the Smith Art Gallery. The gallery, which formed a wing in the enlarged Free Library at Rydings Park, was provided by the then Mayor of Brighouse, Alderman William Smith. The streets were well decorated and many shops received a new coat of paint for the occasion. Perhaps one of the more ambitious displays was that at the crossroads where King Street meets Bradford Road. Here four strings of white, pink and yellow rosettes rose to a large crown in the middle of the cross.

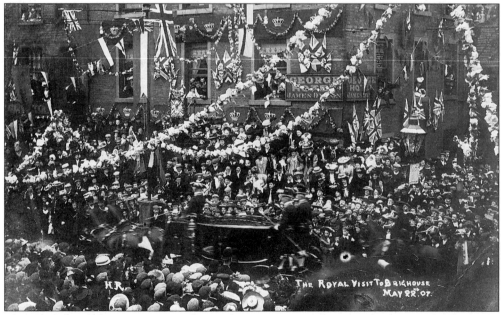

Thousands lined the streets to see the royal procession on what was the first royal visit to the town. However, rather disappointing, particularly for those who had waited hours, was the fact that the Princess rode in a closed carriage and few got so much as a glimpse of her.

Halifax celebrations for the 1911 coronation included the lighting of the Town Hall façade and spire with fairy lamps forming the royal initials and a representation of the crown. The illuminations were admired by the large crowd in attendance and it was reported that certain travellers, having also visited Manchester and Leeds, agreed that Halifax could claim a more creditable display.

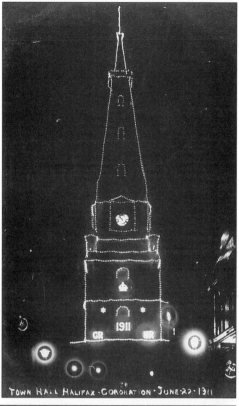

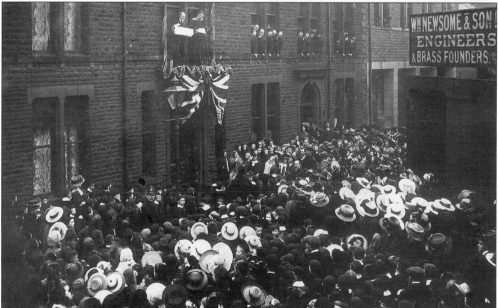

Crowds gathered outside the council offices on Hollins Mill Lane, Sowerby Bridge, for the proclamation of King George V on 10 May 1910. The Chairman of the Council, Councillor A.S. Firth, read the proclamation, accompanied on the platform by the Clerk of the Council, Lewis Rhodes. Note the rather precarious platform erected for the occasion.

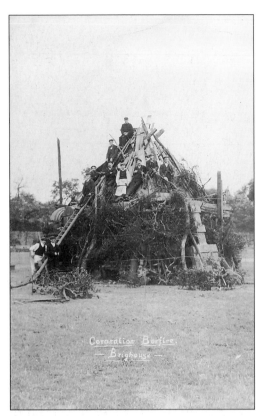

Coronation Bonfire, Brighouse —

As part of the 1911 coronation celebrations in Brighouse, festivities were held in the Lane Head recreation ground. Children from local schools sang *Rule Britannia* and the *National Anthem*, followed by other musical entertainment performed by the Bethel Pierrot Troupe. A daylight firework display was given and as dusk arrived there was a military tattoo followed by a torchlight procession. To complete the events, the Mayoress, Mrs J. Atkinson, applied a torch to the large bonfire, seen here, in the Lane Head grounds.

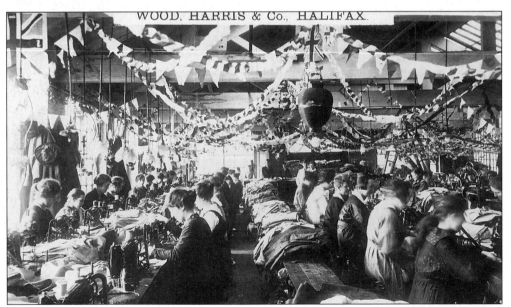

Decorated with abundance, the machining room of Wood, Harris & Company, Halifax, is seen here along with the hard working operatives. The room was decorated to commemorate Armistice Day, 11 November 1918.

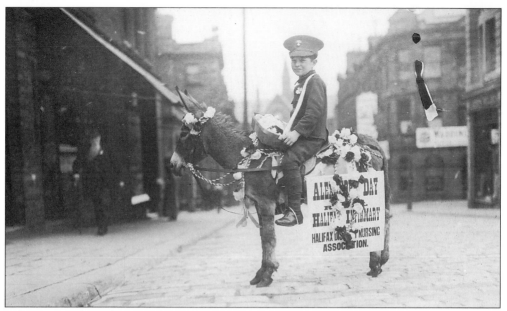

Advertising Alexandra Day, this young lad is sat astride his donkey at the top of Rawson Street.

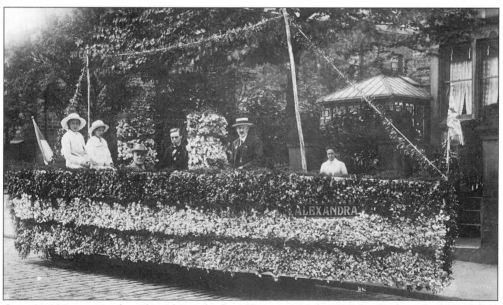

Over £1,000 was raised on the Alexandra Rose Day on 24 July 1915 for the benefit of the Royal Halifax Infirmary and the Halifax District Nursing Association. Around 3,000 ladies managed to sell almost a quarter of a million roses from various locations around the district. A competition and procession of around twenty cars was organised by the Automobile Club; the cars were judged on Skircoat Moor. The main feature, and the winner of the first prize, was the car belonging to the President of the Automobile Club, Mr William Greenwood. The car was surmounted with a framework giving the appearance of a steamer with funnels, the whole finished off with red, white and blue Sweet Peas.

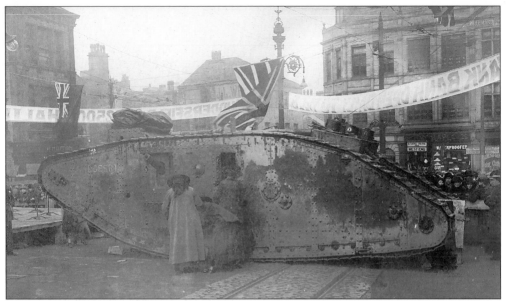

Halifax Tank Week started in earnest with the arrival of the tank *Egbert* on Sunday 18 March 1918. That afternoon an exhibition in manoeuvres was given on the Shay Ground in front of a crowd of over 30,000 people. On Monday morning the tank made the short trip to George Square, a journey that took some three quarters of an hour.

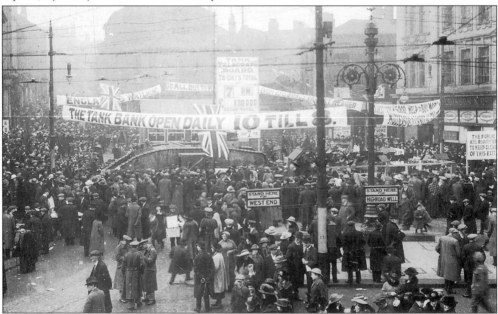

A civic procession was held from the Town Hall and on arrival at George Square, the Mayor, Alderman H. Clay, declared the tank bank open. *Egbert* was the only tank bank circulating the country that had actually been involved in the fighting, having been present at the Battle of Cambrai, the first battle in which British tanks played a significant part. The holes in the tank bore evidence of its active service. By the end of the first day, £630,836 had been collected and by the end of the week, before the tank's departure for Darlington, some £2,335,379, or £23 per capita of the population had been collected.

Prepared by local scouts, presumably with the help of these three gentlemen, this well stacked bonfire was built as part of the Rastrick celebrations of the 1935 Silver Jubilee. Following a gala and firework display at Longroyde Park, a torchlight procession took place to Round Hill where the fire was lit at ten o'clock in the evening to coincide with the lighting of countless other fires around the country.

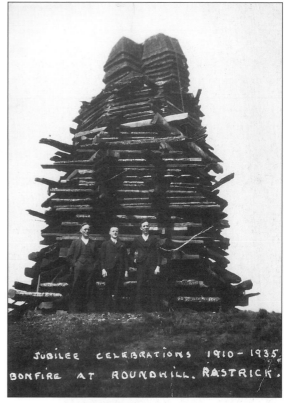

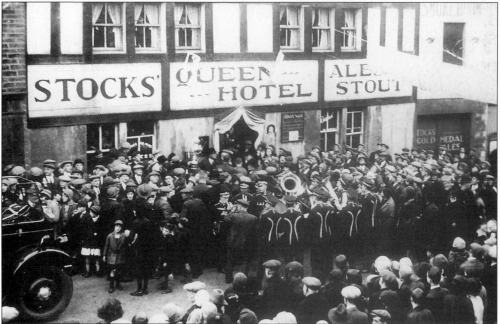

This was the scene in the middle of Ripponden when the victorious Thrum Hall players travelled the district, with the Challenge Cup, having beaten York at Wembley 22-8 in the 1930-31 Cup Final. The cup can just be seen to the left of the Queen Hotel entrance.

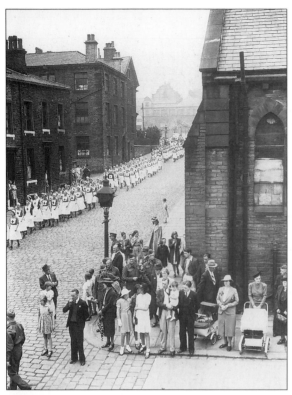

It is believed that this procession passing the Drill Hall, Prescott Street, took place on Saturday 30 September 1939. That day three local detachments of the British Red Cross Society were inspected by Lieutenant Colonel A.C. Sheepshanks, the County Director. 208 people later received various awards.

The nurses of the British Red Cross pass through Bull Green in this photograph taken around 1940. Around this time many processions took place in the town involving members of the Home Services.

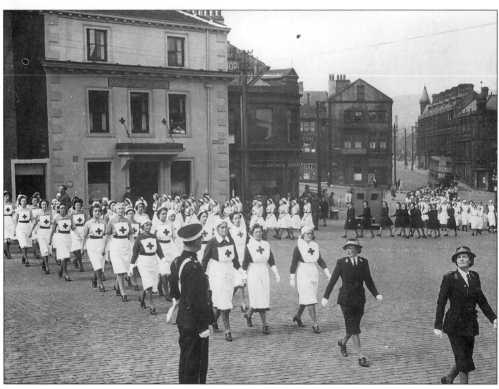

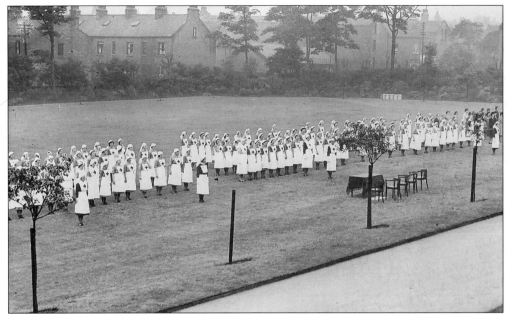

The Princess Royal paid numerous visits to the district. On 13 July 1940 she visited Halifax in her capacity as Commander-in-Chief of the British Red Cross Society. Having inspected the headquarters of the Halifax YMCA, in Union Street, she travelled to the Princess Mary High School. At the school she inspected around 200 officers and nurses of the Halifax detachment of the British Red Cross Society.

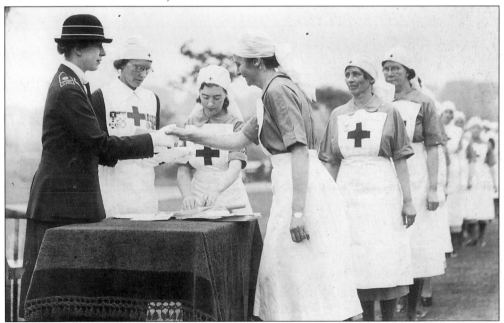

The Princess Royal later presented a large number of first aid, nursing and proficiency certificates as well as three years' service badges. The following year, in October 1941, she paid her twelfth visit to the area when she visited members of the Auxilliary Territorial Services (ATS) and inspected local YMCA centres.

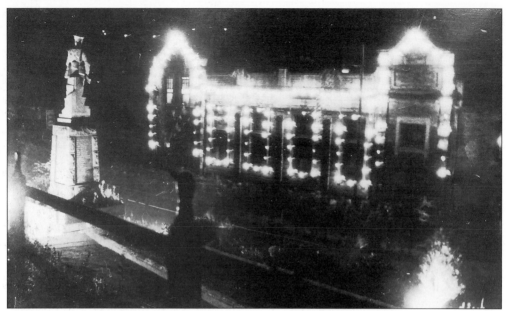

The surrender of Japan in the Second World War came on 14 August 1945 and brought with it the start of two days holiday. The announcement came at midnight and many set off for work the following day unaware that the long awaited VJ Day had arrived. Once informed that it had, they were not slow in returning and joining in the celebrations. At Ripponden the war memorial and Liberal club were illuminated and a large crowd joined in the street dancing.

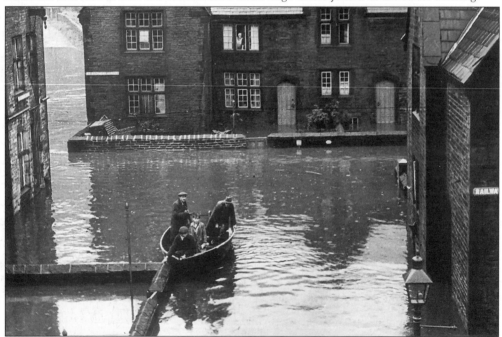

The district has seen, and suffered, its fair share of floods. Many of these are within living memory and perhaps the one most often recalled is that of 1946. With torrential rain causing the Calder to flood, the result was devastating to the areas near the river. Here, at Copley, the normal mode of transport was exchanged for one more in keeping with the situation.